GIFTED WOMAN

by

HOWARD SCHATZ

Edited by Beverly J. Ornstein

Foreword by Laura Nader

PACIFIC PHOTOGRAPHIC PRESS, San Francisco

For information regarding this project or Howard Schatz,
write or call the publisher:
Pacific Photographic Press
P.O. Box 640350
San Francisco, CA 94164-0350
(415) 457-0810

Library of Congress Catalog Card Number: 92-080552
ISBN: 1-881021-00-9

Distributed in the United States by:
Publishers' Group West
4065 Hollis
Emeryville, CA 94608

Book and cover design: Howard Schatz
Cover: Portrait of Evelyn Cisneros, Principal Dancer, San Francisco Ballet
Production: Bookman Productions
Printer: Gardner Lithograph
Printed and bound in U.S.A.

For B.
who makes every joy possible

CONTENTS

FOREWORD

Gifted Woman is a book that celebrates women who have been recognized for their accomplishments. Why should there be a book about us? We are 50 women who live in the San Francisco Bay area and whose efforts are represented in work as artists, musicians, dancers, doctors, writers, culinary artists, activists, professors, women who manage and those who govern, to mention a few categories. Throughout history women have been proud of their accomplishments in the fields of science, literature, medicine and beyond, but women have not always been recognized and their work has not been recorded in spite of high accomplishment. It is by formal recognition, however, that we are allowed entrance into recorded history. No one knows better the bitterness of absent documentation than the historians who are laboring over old science notebooks analyzing myths and poetry or cave paintings to better understand the lives of women's accomplishments never recorded.

Those honored in this book represent a unique generation of women. We are educated, we are recognized nationally and internationally for our achievements, and our accomplishments are being recorded. It may be that at this self-conscious stage in women's history, women's accomplishments are being recorded because such documentation is essential to a balanced history of humanity. Indeed, in the long run the documentation of gifted women may be as important in the scheme of history as our individual contributions because in some respects we are at a turning point in the written record. In addition to European history, Asian history, American history, etc., we now have women's history, an important first step.

Gifted Woman then is a book that documents women's history. Imagine such a book fifty years ago or a hundred years ago and we can appreciate what it has meant to expand the recognition of women's roles. Women's mark on the world can be magnified many times over by this general and mutual recognition.

But what if the compilers of this book were to expand the list of 50 women? Clearly, they would find more physicians, more artists, writers, and businesswomen who would fit the cultural criteria of gifted: women who have excelled, women who by their intellect, their strength, and their passions have marked out areas of intense interest, women who have by their achievement opened new doors, women who are not only gifted but accomplished. Perhaps this is a unique time in human history. Perhaps, but we shall not ever know because the records of women's accomplishments are not only incomplete, but constructed as male history. We do know, however, that certain periods in history yield great contribution and creativity. The Babylonian period was one of creative public participation by women, whereas in neo-Babylonian times the genius of women was not so publicly celebrated or tolerated. Women during the French Revolution and during the Prussian siege of Paris played highlighted roles in reassembling their communities and in articulating legislation. And in many historical periods of tumultuous change women have performed in a "gifted" manner. It was not that suddenly there were more gifted women—the times were more receptive to their "gifts." For women today this is one of those periods in part because the energies unleashed by self-conscious effort has resulted in a great number of gifted women.

But what does it mean to be gifted? What cultural criteria define giftedness? Basically, it is a term that applies to women who set themselves apart or who have been thrust into the limelight. But the very word 'gifted' implies there is a genetic component to our success, which brings to mind the old debate on nature versus nurture—whether we are the result of our biology or our culture. Webster's dictionary defines gifted as "endowed by nature with gifts." However, I don't believe that distinguished women are just gifted, implying ease of achievement. There is effort, dedication, and passion invested in achieving. Yet although many more women could find a place in this book—after all 50 is an arbitrary and clean number— we have to look beyond to women who are not culturally defined as gifted, but who have stretched themselves to extraordinary achievements in ordinary life settings.

If we broaden the cultural criteria, if we were to include women in areas not designated as "gifted" and not nationally and internationally recognized, then we would expand our minds and our world. We would include the artisans — the blue collar workers, the school teachers, the mothers, daughters, and sisters who have achieved their accomplishments in daily living — building and repairing homes and houses, teaching children, safeguarding community lands and improving the quality of life for millions of people. Look at what happens when women who work double shifts — one at work, the other at home — are unable to volunteer in our school, our hospitals, our homes and our communities.

"Gifted" women produce quality accomplishment with and without recognition. The characteristics shared by women of accomplishment are the opposites of hopelessness, mediocrity, or incompetence. Intensity of purpose and focus of interest resulting in meaningful quality performance contributes to national and global treasure and is a large part of understanding why society goes forward or backward.

Laura Nader
Berkeley, California

PREFACE

The women who grace these images have all made an indelible impact on the San Francisco Bay Area community and the region as a whole. Continuing in the tradition of the western pioneer, they have all been and continue to be dramatic forces in the evolution of the role of women in our society. Not only do these women possess a rare natural ability and talent, but in addition they have chosen to share their gifts with the world.

It is appropriate that these photographs, dealing with the subject of gifted women, should spring from California and the Bay Area. Women have always held a unique place in California history. Over time, thousands of women came to California, where they were able to begin new lives in a freer, more open environment. As early as Gold Rush days when women represented a tiny minority, they were granted greater legal rights here than elsewhere. In the 19th century, California was the first state to recognize women's equal rights by recognizing their contribution to the family, giving them an equal share in all property held by husband and wife. California was also among the earliest states to grant women the right to vote, with suffrage coming in 1911. Here, women found the freedom to express themselves in a less traditional and gender-dominated society. California and the Bay Area have served as an oasis for the individual, male or female, to find a new and better life than they left behind.

Until recently the role of women in California's history has been ignored. "Women have constituted the most spectacular casualty of traditional history," writes historian Arthur M. Schlessinger, Jr. "They have made up at least half of the human race; but you could never tell that by looking at the books historians write."

Beginning with the equal rights movement of the 1960's and 1970's, women's voices became increasingly stronger, and through the women's movement, the documentation of their role

in history gained new stature. This movement in which Bay Area women played an active role, brought women's history and issues to the forefront of public attention. Today, the contributions of women have renewed impact on American society. No longer are their stories left untold, or are rigid limitations placed on the role they will play in society and in the outcome of their own lives. Women today continue the struggle to retain and expand the rights for which they have fought. It is an ongoing battle for recognition of skills and abilities rather than gender.

The portraits of the "Gifted Woman" series reproduced on these pages, and their accompanying biographies, provide us with an opportunity to learn about the important contributions of these exceptional and innovative women. The Oakland Museum believes that these images will provide a chronicle of the evolving role of California women for future generations.

Marcia Eymann
Oakland Museum

PORTRAITS

RUTH BERNHARD

Photographer

Ms. Bernhard began her career studying art history and typography at the Academy of Fine Arts in Berlin. She came to New York in 1927 and began photographing in 1930. Although her early work was largely commercial, her meeting with Edward Weston in 1935 changed her entire approach and she began making more intuitive photographs. Her first artistic recognition came with an exhibit of her work in Los Angeles in 1936.

Since the 1960's, Bernhard has been teaching workshops and private classes on photography entitled: Photographing the Nude, The Art of Feeling *and* Seeing and Awareness. *Bernhard began photographing the nude as early as 1934 and she did the majority of her work on the nude female form in the 50's and 60's. Her book,* Ruth Bernhard: The Eternal Body, *is the collection of that work and one of photography's best-sellers.*

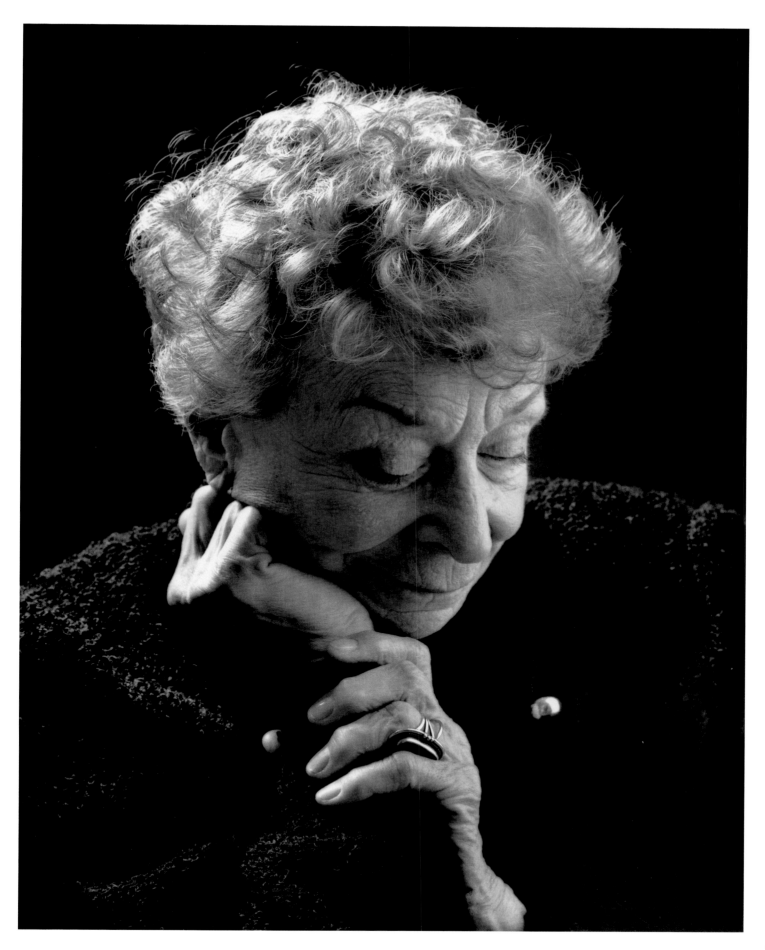

NANCY SNYDERMAN, MD

Physician, Journalist

Nancy Snyderman is an Associate Professor of Otolaryngology—Head and Neck Surgery at the University of California Medical Center, San Francisco. She has published dozens of scholarly articles on diseases and trauma of the head and neck, received grants from the American Cancer Society and the Kellogg Foundation and was a visiting professor at the All-Union Cancer Center in Moscow in 1990. Since 1983, Dr. Snyderman has also worked as a professional journalist and is presently a medical correspondent for ABC's Good Morning America *and the* CBS *affiliate KPIX-TV in San Francisco.*

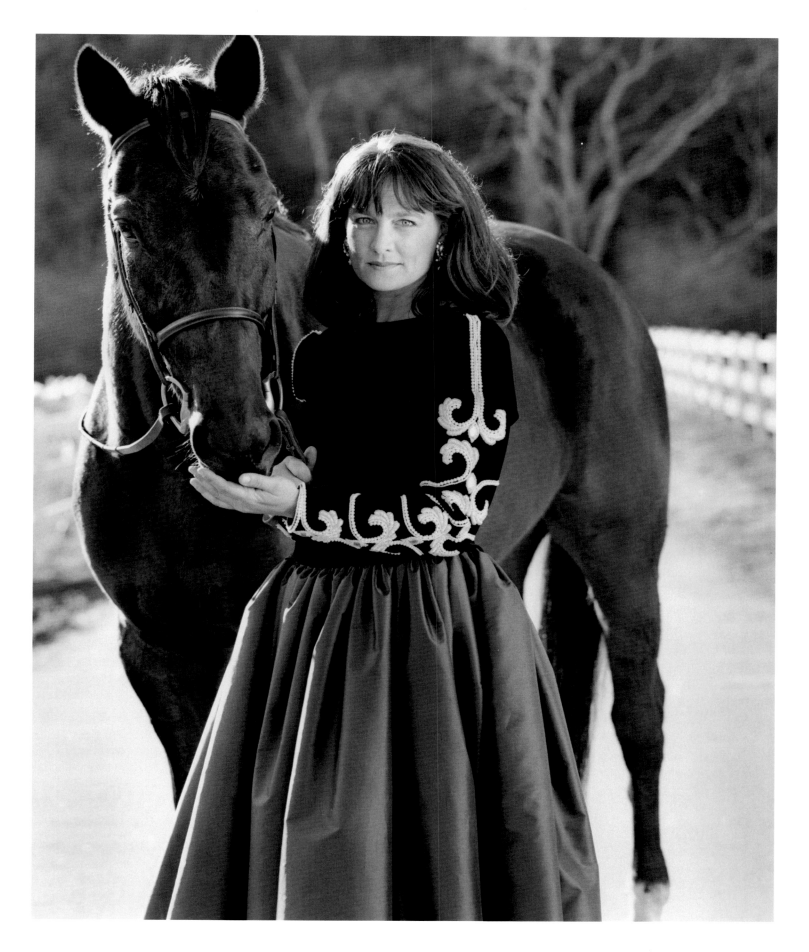

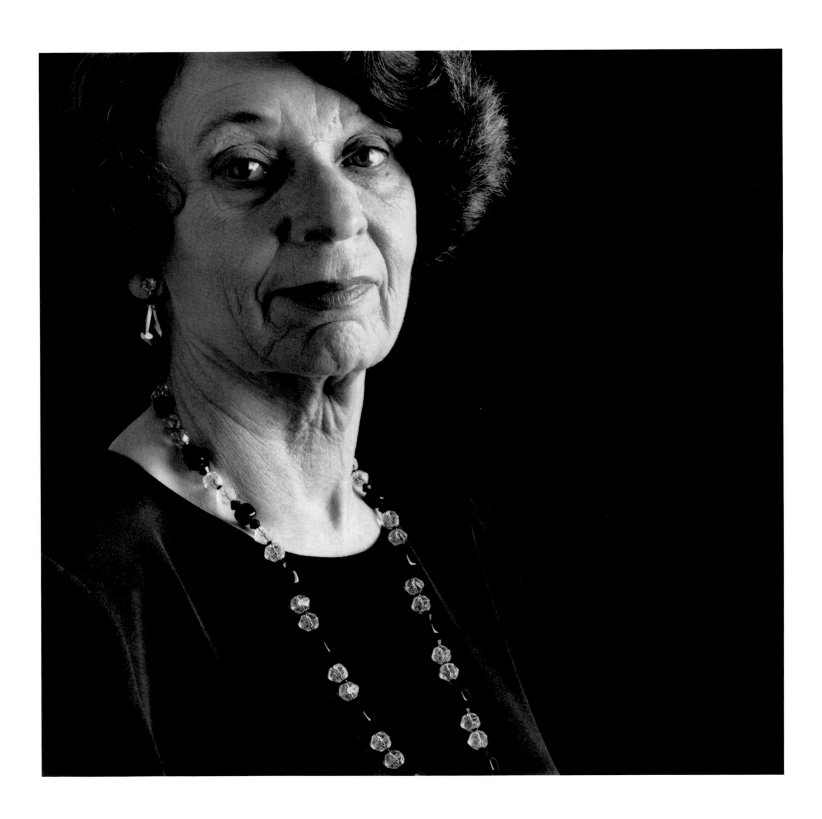

JUDITH WALLERSTEIN, PhD
Psychologist

"I regard her as the world's foremost authority on the effects of divorce on children," says Justice Donald King of the California State Court of Appeals. Dr. Wallerstein's pioneering work has had an immense impact on family law and social policy nationwide. She is best known for her California Children of Divorce Project, *the longest sustained inquiry of its kind ever done. Her bestselling books,* Surviving the Breakup *(1980) and* Second Chances: Men, Women and Children a Decade After Divorce *(1989) and scores of professional and popular articles have revolutionized the understanding of divorce and its aftermath.*

Since 1980, Wallerstein has directed the Center for the Family in Transition, an agency which counsels divorcing families and trains practitioners from various disciplines who do similar counseling. She has written numerous articles on the effects of divorce on children and lectures extensively in the United States and abroad.

BELVA DAVIS

Journalist

Davis is a television journalist with over thirty years of reporting experience in the San Francisco Bay Area. She was the first black woman television journalist on the West Coast. She began her career as a journalist reporting for Jet *magazine, the* Bay Area Independent *and the* San Francisco Sun-Reporter. *Her early work in broadcasting was on radio:* KSAN, KEWB, KDIA *and* KJAZ. *In 1966, Davis began her television career at* KPIX-TV, *Channel 5, where she eventually anchored the news for the first time. Her years at* KPIX *include several seasons with* All Together Now, *a prime-time program which she pioneered. From 1977 to 1980 she anchored the nightly news for* KQED, *the Public Television station and since 1981 she has been the Urban Affairs Reporter for* KRON-TV, *the* Chronicle Broadcasting Company *in San Francisco.*

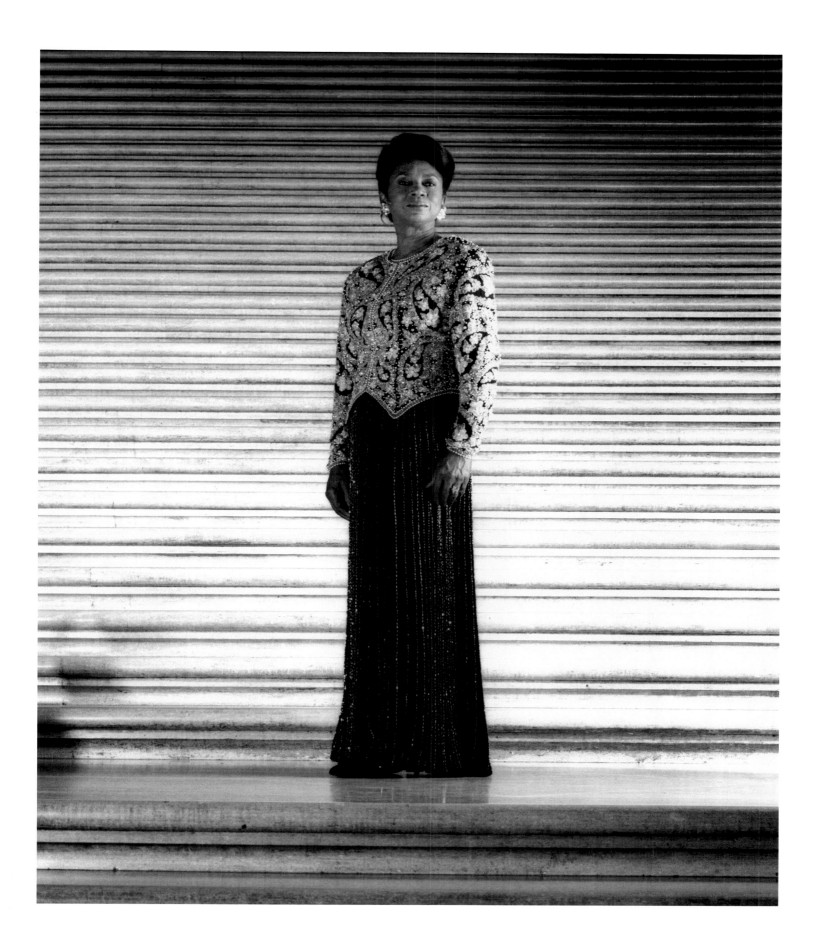

BARBARA BOXER

Congresswoman

Boxer entered the national political arena as Congressional Representative from California's 6th District in 1983. She has served on the Government Activities and Transportation Subcommittee of the Government Operations Committee, the Armed Services Committee, and the Human Resources Task Force of the Budget Committee. Her tenure on the Hill has also included service as House Whip At-Large, Co-Chair of the Military Reform Caucus, founder of the Local Government Task Force and service on the Human Rights Task Force. She was elected president of her freshman class in Congress for her work on military spending procedures during her first term. Prior to her election to Congress, she served on the Marin County Board of Supervisors (from 1976 to 1982); she was elected the first woman President of the Board in its 131-year history.

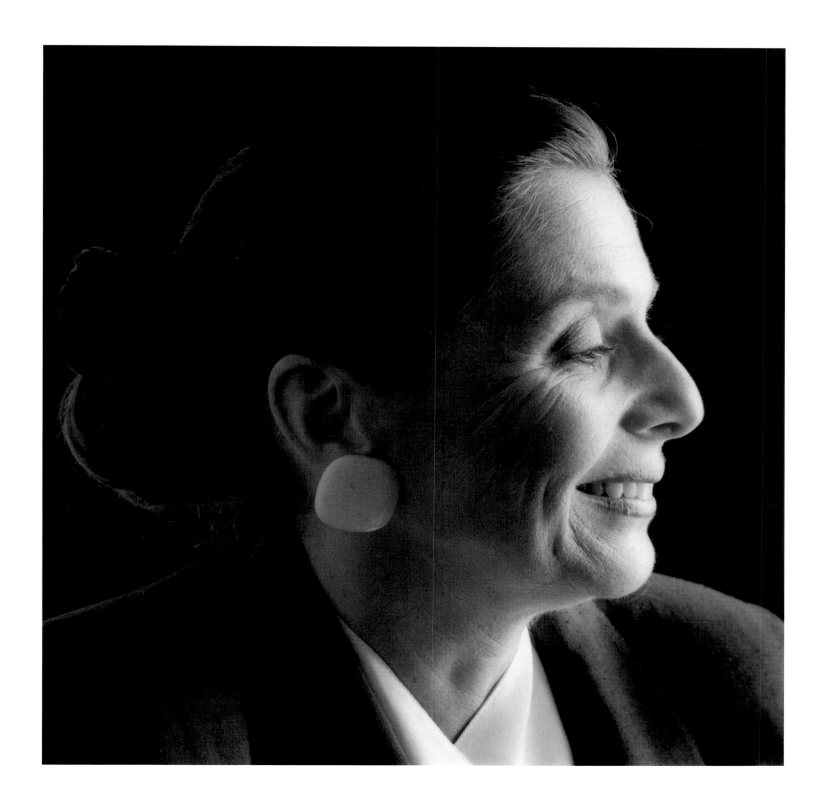

WANDA CORN, PhD
Art Historian/Stanford University

Distinguished scholar and teacher of the history of American art. She is on the faculty of Stanford University where she has served as chair of the Department of Art and acting director of the Stanford Museum. She is presently the Anthony P. Meier Family Professor and Director of the Stanford Humanities Center.

Wanda Corn's scholarship has focused on late nineteenth and early twentieth century painting and photography. Her books and museum exhibitions include:

The Color of Mood: American Tonalism 1880–1910, (1972)
The Art of Andrew Wyeth, (1973)
Grant Wood: The Regionalist Vision, (1983)

The focus of her most recent work has been on cultural nationalism in early American modernism.

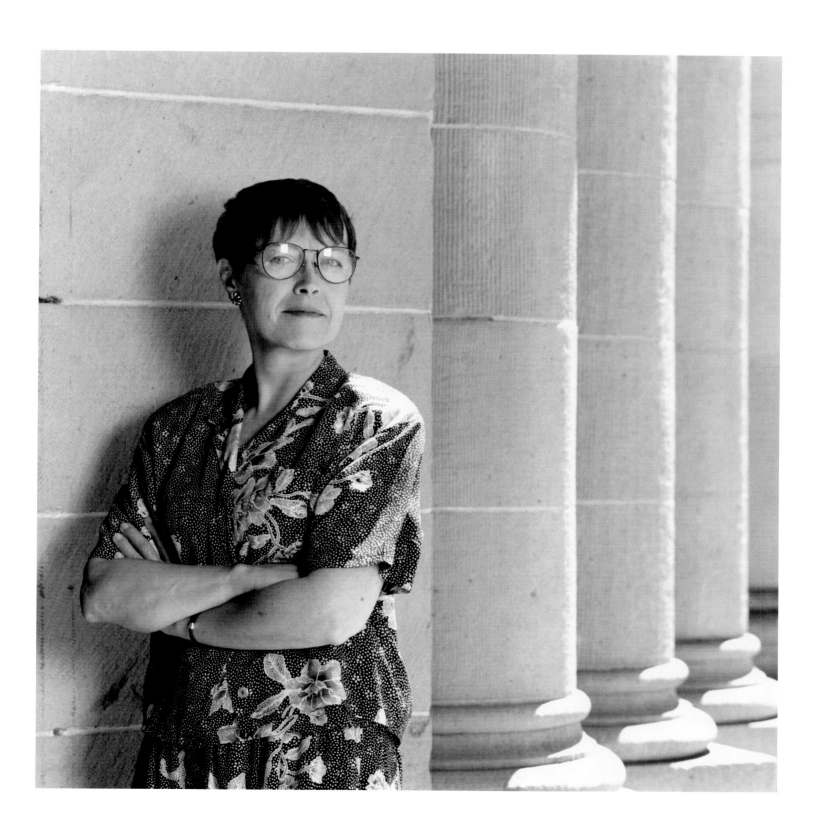

MIMI FARINA

Musician/Founder "Bread and Roses"

*Mimi Farina is a musician and singer
with five albums to her credit.
She is the founder and director of
"Bread and Roses," a non-profit
organization created in 1974 which
provides professional entertainment
for San Francisco Bay Area
convalescent homes, psychiatric
wards, substance abuse
rehabilitation centers, homes
for the developmentally
handicapped, psychiatric and
correctional facilities, AIDS wards
and homeless shelters. "Bread and
Roses" organizes the shows and
provides the entertainers for over
45 shows a month.*

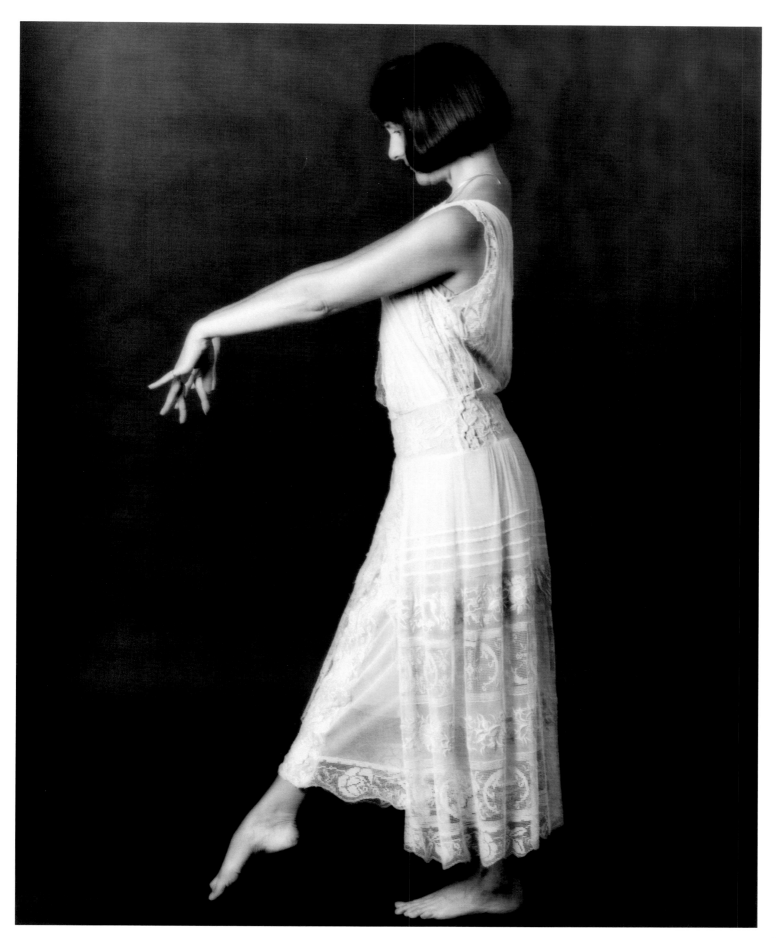

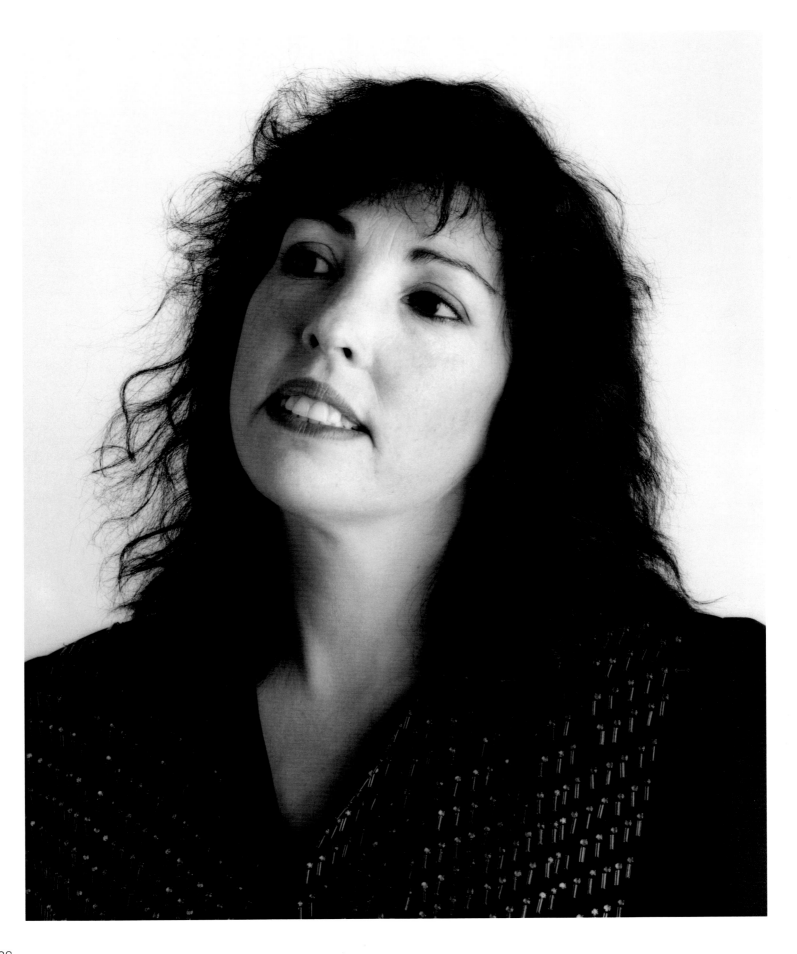

DIANA REISS
Dolphin Language Researcher

Specialist in speech and communication science, since 1980, Research Director and Principal Investigator Project Circe, research in dolphin communication, behavior and cognition. She is the author of a dozen articles on communication among whales and dolphins as well as the book, Secrets of the Dolphins. *She was one of the organizers of the SETI Symposium (Search for Extraterrestrial Intelligence), of the California Academy of Sciences, sponsored by NASA Ames Research Center; she is a member of the Board of Directors, Marine World Foundation; the Scientific Advisory Board, the California Marine Mammal Center; the Scientific Advisory Board of the Earth Island Institute; and the Scientific Board of Directors of the Wild Dolphin Project, Miami, Florida.*

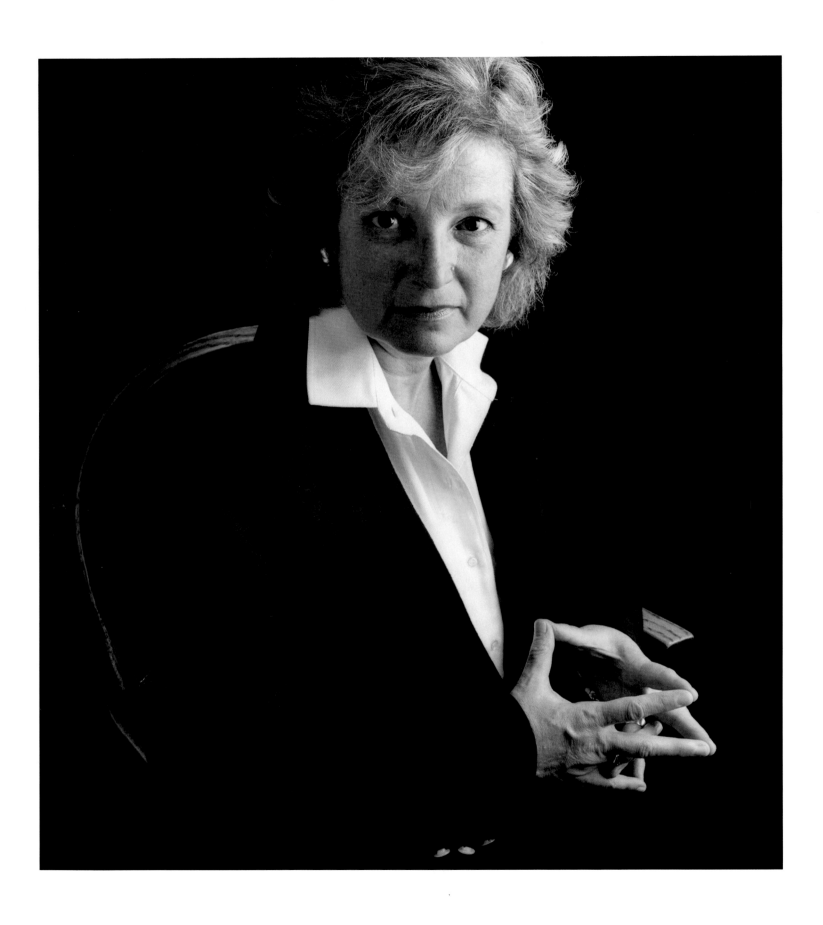

LENORE TERR, MD
Child Psychiatrist

Child psychiatrist in private practice; Clinical Professor of Psychiatry at the University of California Medical Center, San Francisco; Lecturer in Law and Psychiatry, University of California at Davis and one of eight national directors of the American Board of Psychiatry and Neurology. Dr. Terr began studying childhood psychic trauma during the early 1960's and her long-term studies of the Chowchilla Schoolbus Kidnapping victims laid out what are now considered the "classical" symptoms of childhood trauma. She was awarded the Ittleson Prize of the American Psychiatric Association, the highest prize in American child psychiatric research, for the Chowchilla project.

Other major projects include the study of the adult effects of childhood trauma; the study of how traumatic memory from childhood is retained or forgotten; a study of the reactions of normal American school children to the Challenger spacecraft tragedy; and an investigation of the psychological effects of the East Bay fire storm on very young children. She is the author of over three dozen articles which focus primarily on the study of childhood trauma including child abuse, kidnapping and the experience of children in the courts as well as Too Scared To Cry, *a book about childhood psychic trauma.*

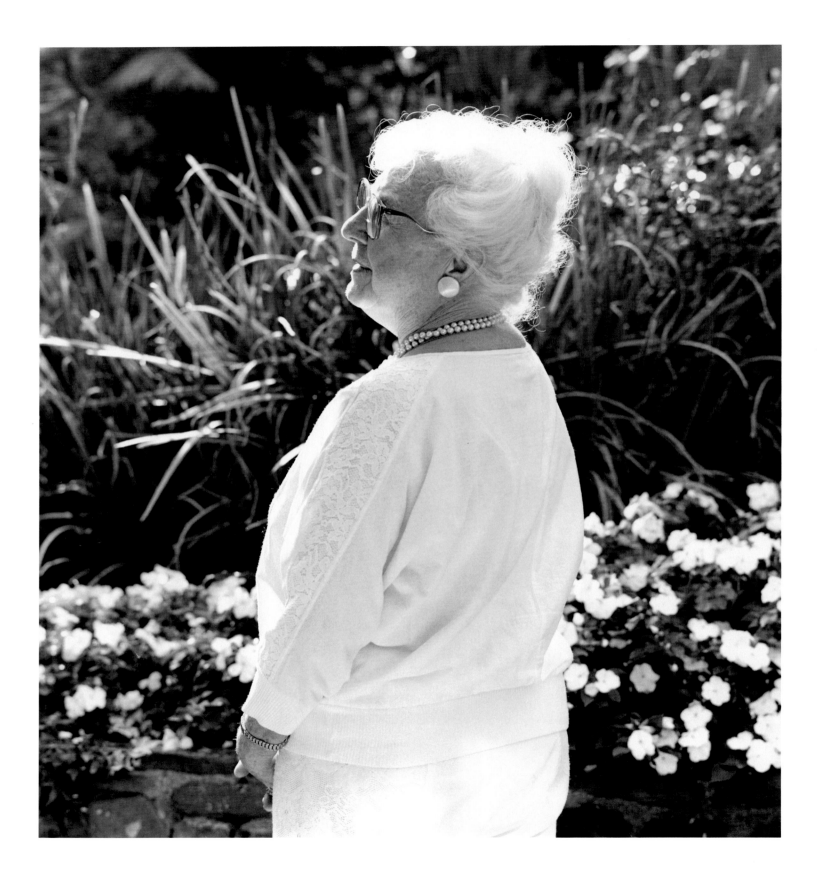

GLADYS VALLEY
Builder/Philanthropist

Gladys Valley and her husband Wayne began their real estate development company in 1940— the year they got married. During the next half century, their companies built over a quarter of a million houses, primarily in California, Arizona, Texas, Florida, Mississippi, Alabama and Georgia. Their focus was on building for the first-time home-buyer.

A life-long interest in athletics and sports lead to their work as the founders of the Oakland Raiders professional football franchise.

In 1985 they formalized what had been a ongoing commitment to philanthropy with the establishment of the Wayne and Gladys Valley Foundation. Its two primary goals are to further education at all levels and to fund medical and scientific research. The profits from the building enterprise now fund the work of the foundation.

Since her husband's death in 1986, Ms. Valley has continued as head of the foundation; she oversees all of its philanthropic work. She still manages hands-on the work of her real estate development interests.

JANICE MIRIKITANI
Poet/Author/President, Glide Corporation

Mirikitani is the author of two books of prose and poetry:
Shedding Silence, 1987
Awake in the River, 1978

She served as Project Director and Editor of AYUMI, a Japanese American Anthology, spanning four generations. She is co-editor of a new Asian Women's Anthology, a project of Asian Women United, entitled "Making Waves." Her most recent project is a publication by women and men who are survivors of incest and sexual abuse.

As Director of Programs at Glide Church and Urban Center and the President of the Glide Corporation, Mirikitani is responsible for the administration and direction of 28 different community services ranging from women's health and AIDS/HIV programs to recovery, education, job training and placement programs.

In her 25 years at Glide Church/ Urban Center, Mirikitani has created a comprehensive creative arts program which includes a theatre group, dance, writing, and multi-disciplinary performance groups. She has served as director and choreographer for the Glide Dance Ensemble for 19 years.

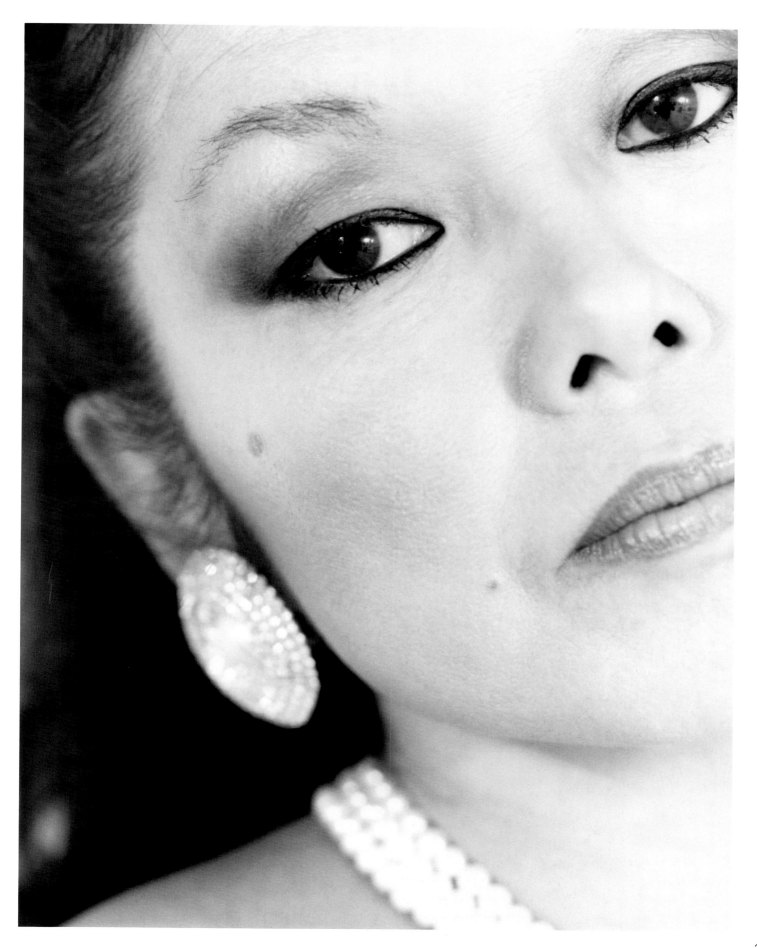

MIMI KOEHL, PhD

Professor of Zoology / University of California, Berkeley

Dr. Koehl is a Professor of Integrative Biology at the University of California, Berkeley. Her work is in the fields of biology and engineering; she studies the biomechanics of animals and plants. Her research has ranged from investigations of the hydrodynamics of microscopic marine animals to the aerodynamics of the evolution of insect wings to the physics of how developing embryos take shape. She is a winner of a MacArthur Foundation "genius" Award, one of the first recipients of the Presidential Young Investigator Award, and winner of a Guggenheim Fellowship, as well as of numerous other fellowships and grants.

She is the author of over 40 scholarly articles and her work has been featured in the popular press in the United States, Japan and Canada. Her invitations to lecture include:

Helen Homans Gilbert Lectureship at Harvard
Cocos Lectureship at Duke
Distinguished Ocean Scholar at Cornell
H. Burr Steinbach Lectureship at
Woods Hole Oceanographic Institution

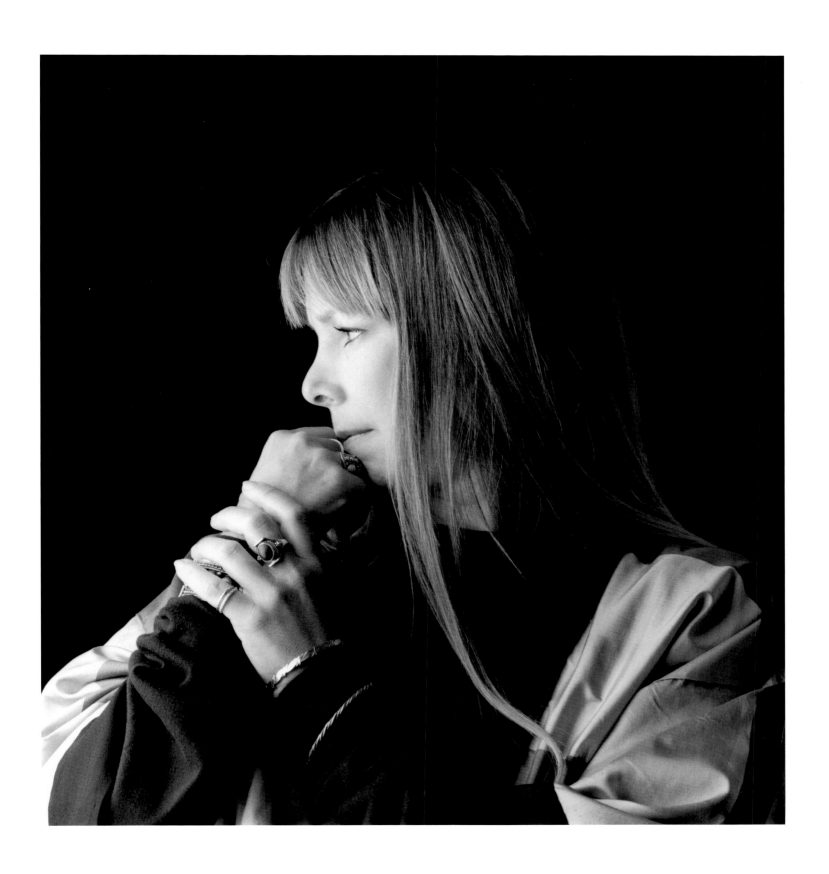

LAURA NADER, PhD

Cultural Anthropologist/University of California, Berkeley

Dr. Nader is a cultural anthropologist whose work has focused on the role of law in society. Her seminal work on the culture and lives of the Zapotec Indians in Mexico, Harmony Ideology: Justice and Control in a Mountain Zapotec Village, *was published by Stanford University Press in 1990. Dr. Nader, the first woman professor of Anthropology at the University of California at Berkeley, has been there since 1960.*

Dr. Nader is the author of several books and over 100 wide-ranging articles that include work on law, women, children, science, and energy policy. She was the subject of the PBS *film,* Little Industries: Laura Nader Looks at the Law. *She is an outspoken activist and one of this country's most perceptive analysts of the ways in which social and cultural controlling processes impede or encourage the full development of the common ground that is made up of the individuals who live in society.*

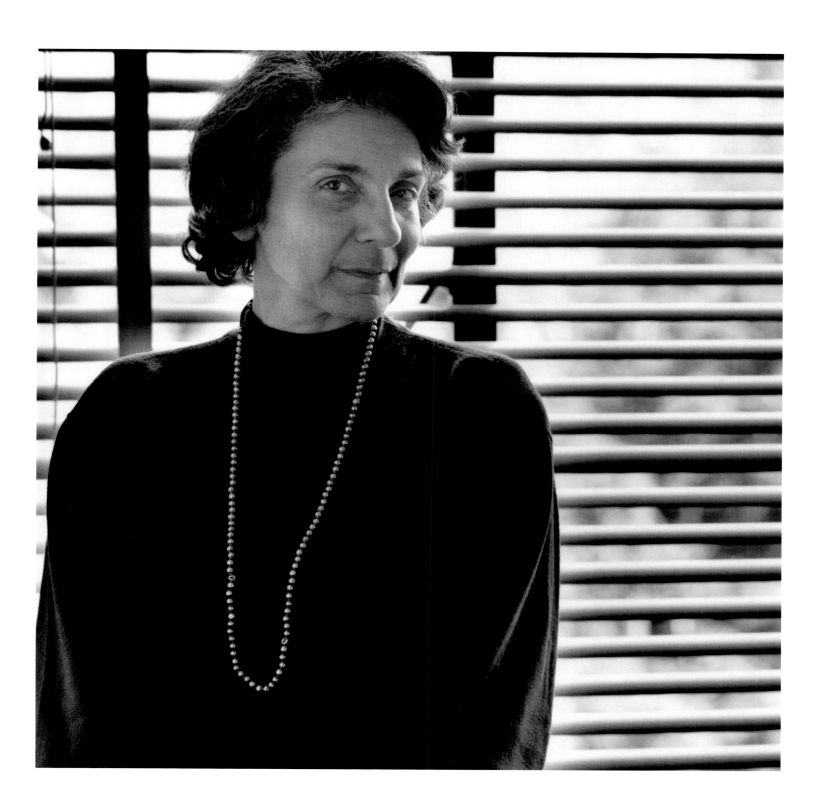

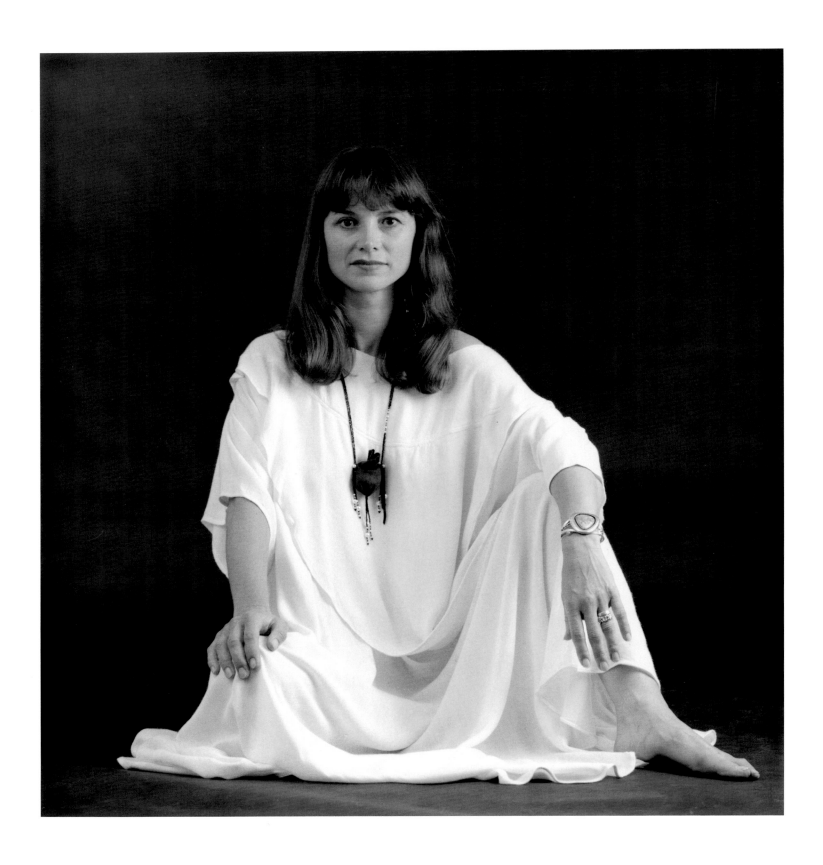

VIVIENNE VERDON-ROE

Documentary Filmmaker

Vivienne Verdon-Roe is a documentary film producer and co-founder and president of The Video Project, a non-profit organization which serves as a resource for low-cost videos on environmental issues. She is the producer of four major documentaries:

In the Nuclear Shadow: What Can the Children Tell Us?
What About the Russians?
The Edge of History
Women — For America, For the World

In the Nuclear Shadow *was nominated for an Academy Award.* Women — For America, For the World *won the Academy Award for best documentary in 1986.*

DEBI THOMAS

Figure Skater

Debi Thomas is a world-class figure skater, winner of numerous championships:

1986 U.S. National Championships — 1st Place
1986 World Championships — 1st Place
1987 U.S. National Championships — 2nd Place
1987 World Championships — 2nd Place
1988 Olympics Women's Figure Skating — Bronze medal winner
1988 World Championships — 3rd Place
1988 World Professional Figure Skating Championship — 1st Place
1989 World Professional Figure Skating Championship — 1st Place

In June of 1991 she graduated from Stanford University in General Engineering. It is her goal to become an orthopaedic surgeon specializing in sports medicine and to use her engineering background in the area of biomechanics in the development of prosthetic devices. She is still skating and touring professionally.

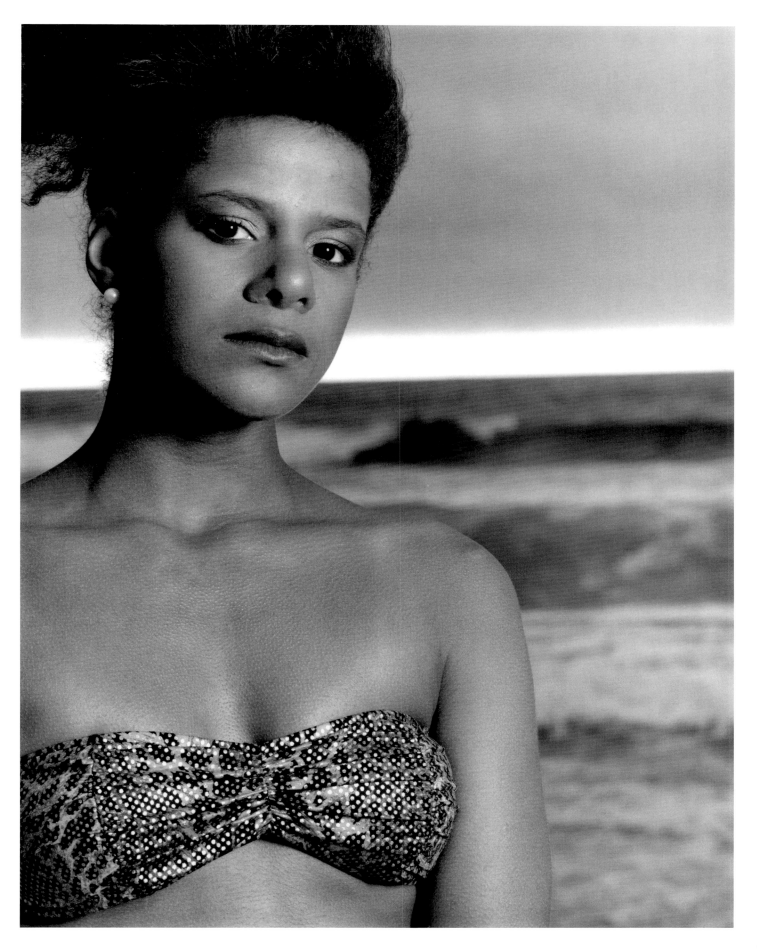

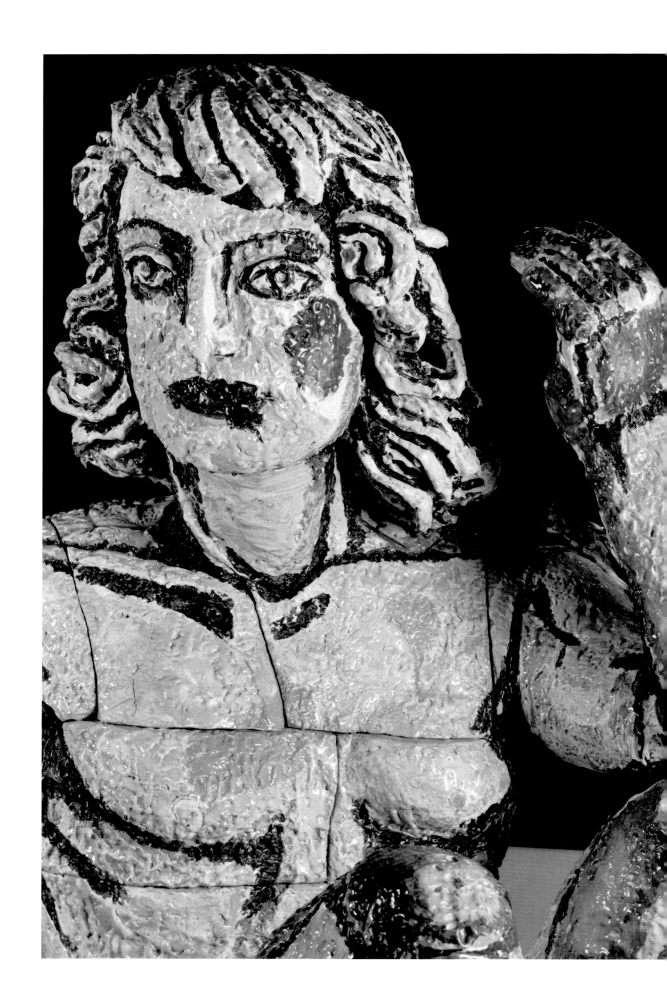

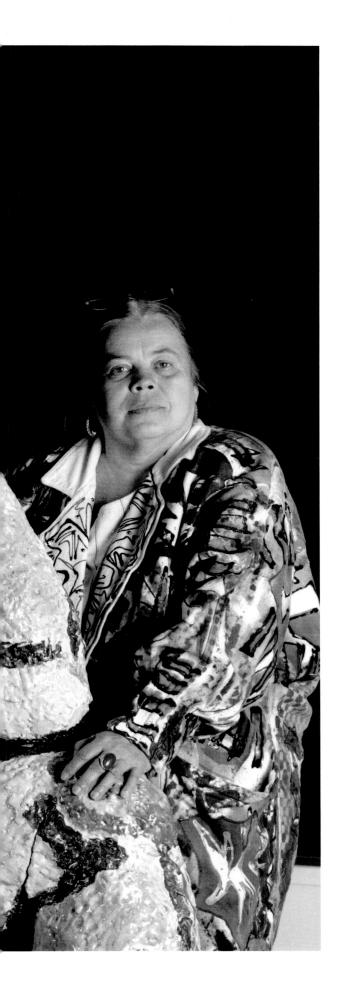

VIOLA FREY
Sculptor/Painter/Ceramic Artist

Since 1953, Ms. Frey has lived and worked in San Francisco and Oakland. She is internationally known for her work — primarily for her heroic ceramic figures (seen with her in the photograph taken at the installation of a 1991 show at the Rena Bransten Gallery in San Francisco). Her work has been exhibited in galleries and museums all over the country, among them the Whitney Museum of American Art and the American Craft Museum, both in New York, the Oakland Museum and the Crocker Art Museum in Sacramento. Her work is also found in numerous private collections.

EVELYN CISNEROS
Principal Dancer/San Francisco Ballet

*Cisneros was awarded the
1989 Isadora Duncan Performer's
Award by the Bay Area Dance
Coalition; the 1989 La Raza
Lawyer's Association Award for
Outstanding Achievement in the
field of the performing arts;
1987 Outstanding Member of
the Hispanic Community by the
National Concilio of America;
1986 Outstanding Young American
by* Esquire *magazine.*

DEL MARTIN and PHYLLIS LYON

Women's Rights Activists

In 1955, Del Martin and Phyllis Lyon collaborated with six other women in San Francisco to found the Daughters of Bilitis, the first international lesbian organization. Lifelong civil rights activists, after 1955 their work was primarily with women, lesbians and gay men. In 1964 they co-founded the Council on Religion and the Homosexual, and in 1965 they co-founded Citizens Alert, a coalition of civil rights groups dealing with citizen complaints against police brutality.

In 1972 Martin and Lyon were among the founding members of the Alice B. Toklas Memorial Democratic Club. They are co-authors of the ground-breaking book, Lesbian/Woman in 1972. Lyon is a journalist, author, and Professor Emeritus at the Institute for Advanced Study of Human Sexuality in San Francisco. She served on the San Francisco Human Rights Commission from 1976–1987, and as chairperson in 1982 and 1983. Martin is the author of Battered Woman and a nationally recognized advocate for battered women. She is a co-founder of the Coalition for Justice for Battered Women, La Casa de las Madres shelter for battered women, and the California Coalition Against Domestic Violence. She served on the San Francisco Commission on the Status of Women from 1976 to 1979, and was chair in 1976–77.

In December of 1990, Martin and Lyon were honored by the ACLU of Northern California with their highest award: the Earl Warren Civil Liberties Award.

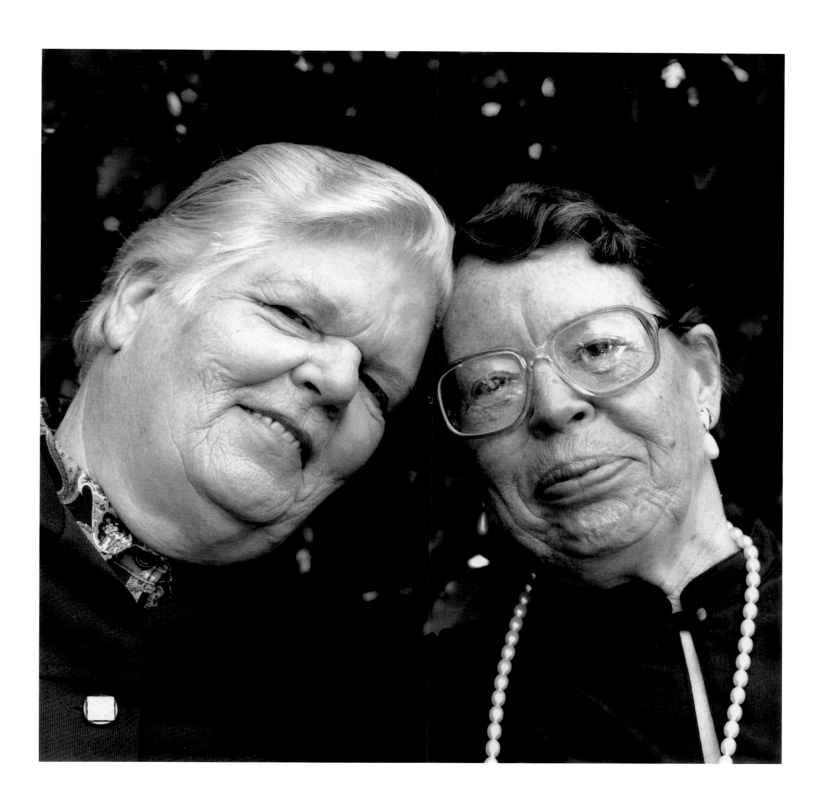

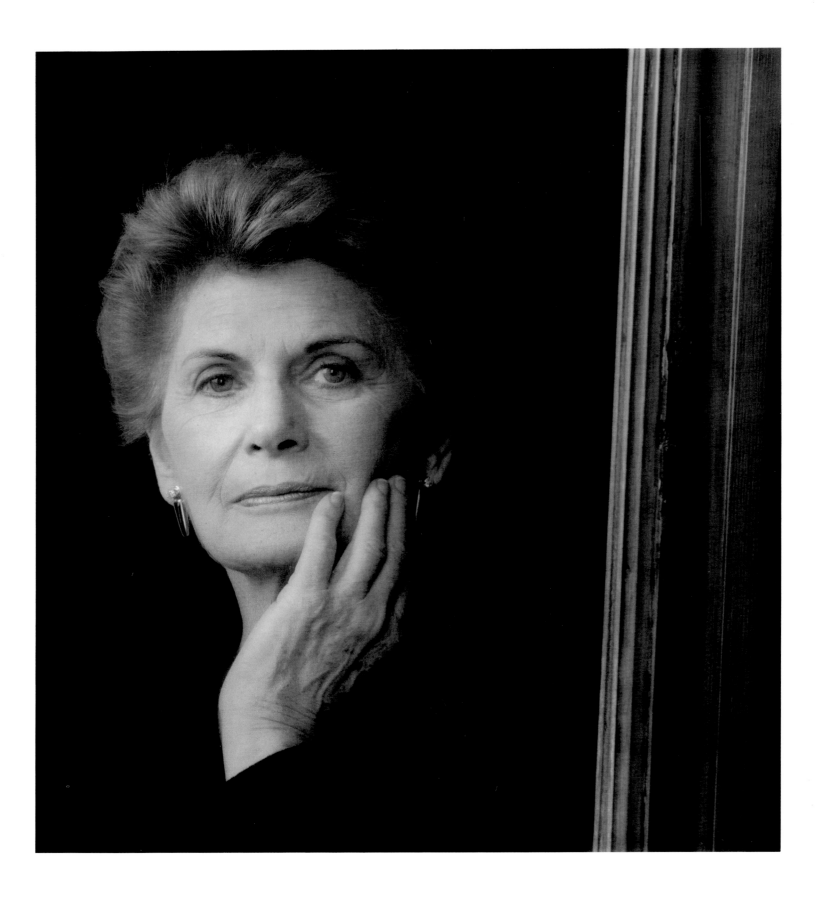

LILLIAN RUBIN, PhD
Sociologist, Author

Sociologist, psychologist and the author of numerous books including:

Worlds of Pain: Life in the Working Class Family

Women of a Certain Age: The Midlife Search for Self

Intimate Strangers: Men and Women Together

Just Friends: The Role of Friendship in Our Lives

Quiet Rage: Bernie Goetz in a Time of Madness

Erotic Wars: What Happened to the Sexual Revolution?

She is Alumni Professor of Interpretive Sociology, Queens College, City University of New York, and Senior Research Associate at the Institute for the Study of Social Change, University of California, Berkeley.

RUTH ASAWA

Sculptor and Artist

Asawa has over fifteen public and private commissions for art in public space to her credit. Her work has been exhibited in over forty group and solo exhibitions. She is known primarily for her humorous and humane sculpture—perhaps her most famous pieces are the bronze fountains at the Hyatt Union Square and Ghirardelli Square in San Francisco. She considers her woven and tied wire sculptures that are suspended from the ceiling or hung on the wall as her most serious work. They hang in profusion in her home and provide the backdrop for this portrait.

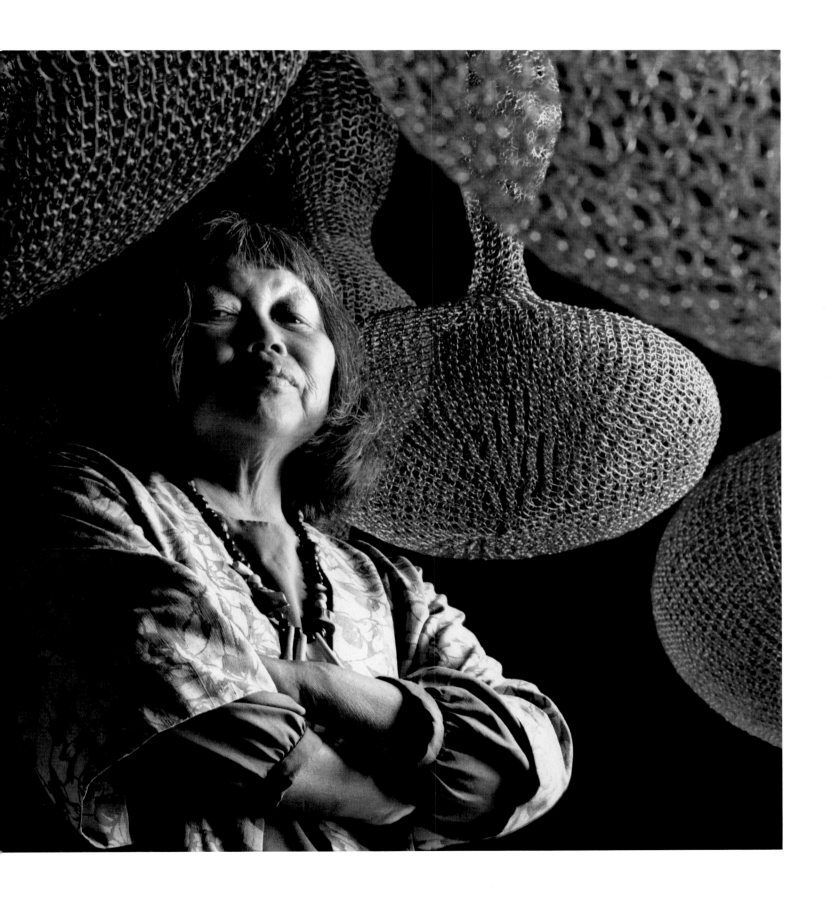

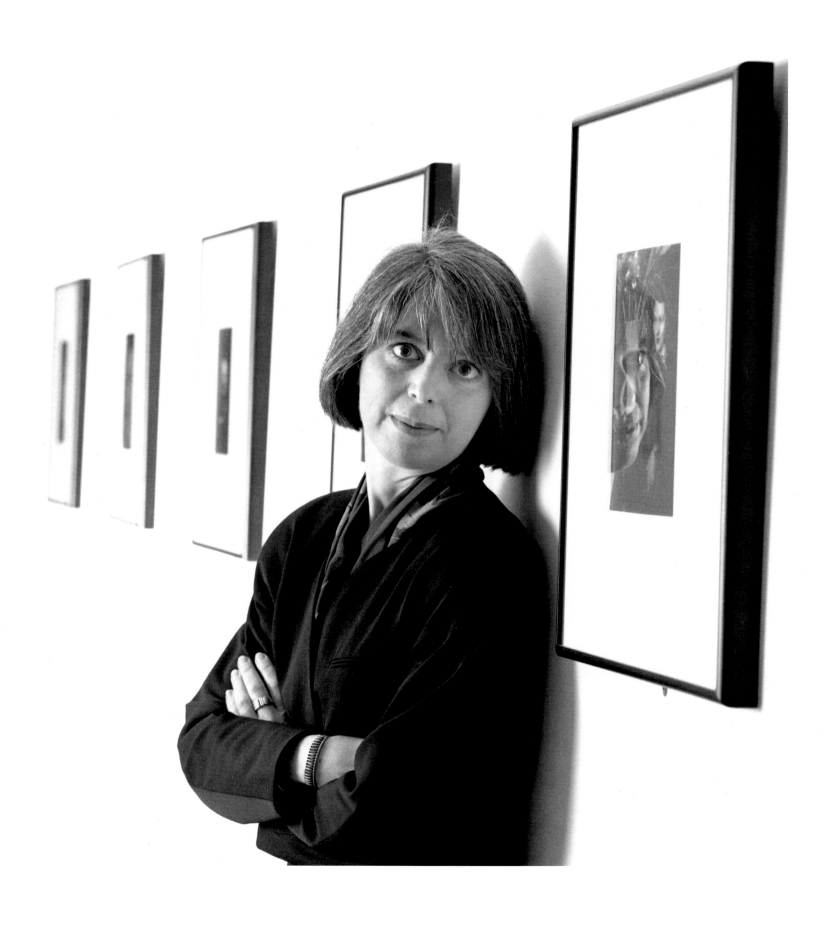

SANDRA PHILLIPS, PhD
Curator of Photography: San Francisco Museum of Modern Art

Sandra Phillips is an art historian and, since 1987, Curator of Photography at the San Francisco Museum of Modern Art. She is responsible for curating all of the exhibits of photography at the Museum of Modern Art including, during her tenure:

Helen Levitt, 1991
Sabastiao Salgado, 1990
The Work of John Gutmann, 1989
Stuart Klipper and Rhondal McKinney, 1989
Experimental Color in Photography, 1989
Real Fictions: Photographs by Bill Dane, John Harding and Larry Sultan, 1989
A History of Photography from California Collections, 1989
Siegel, Josephson and Jachna, 1988
William Wegman, 1988

She has contributed essays to a number of volumes on photography, including:

Perpetual Motif: The Art of Man Ray
The Eyes of Time: Photojournalism in America
Andre Kertesz: Of Paris and New York

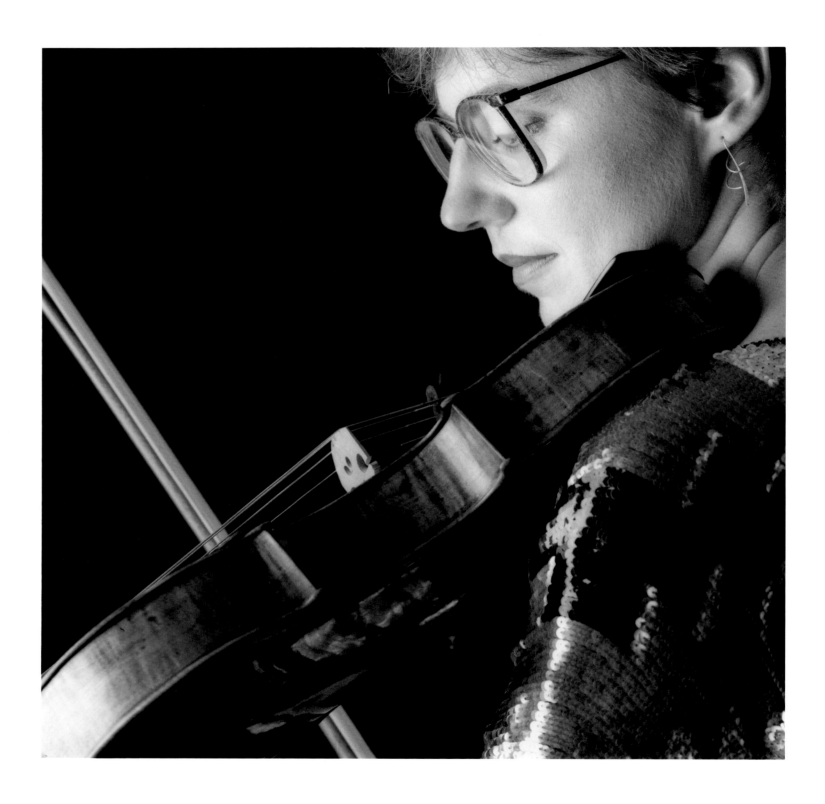

GERALDINE WALTHER

Violist

*Principal Violist with the
San Francisco Symphony since
1976. She was the first winner of
the William Primrose International
Viola Competition in 1979, and she
frequently appears as soloist with
orchestras and ensembles in the
San Francisco Bay Area,
throughout the United States
and abroad. She is soloist on the
San Francisco Symphony's
London Records recordings of
Hindemith's "Travermusik"
and his viola concerto
"Der Schwanendreher".*

*Ms. Walther has performed
at numerous music festivals
including: Marlboro Music Festival,
Tanglewood, Eastern Music Festival
in North Carolina, Telluride Festival,
Marin Music Festival,
Chamber Music West, Strings in
the Mountains, and the Santa Fe
Chamber Music Festival. She is
founder of the Soldier Creek Music
Festival and Chamber Music
Sundaes, a Bay Area series run
by and featuring San Francisco
Symphony musicians.*

JESSICA MITFORD

Author

Jessica Mitford was dubbed "Queen of the Muckrakers" by a Time *magazine reviewer. She has spent the majority of her writing career exposing the underside of American life. Her most famous exposés include:*

The American Way of Death:
Kind and Usual Punishment
The Prison Business
Poison Penmanship:
The Gentle Art of Muckraking

She has also written two volumes of autobiography:

A Fine Old Conflict
Daughters and Rebels

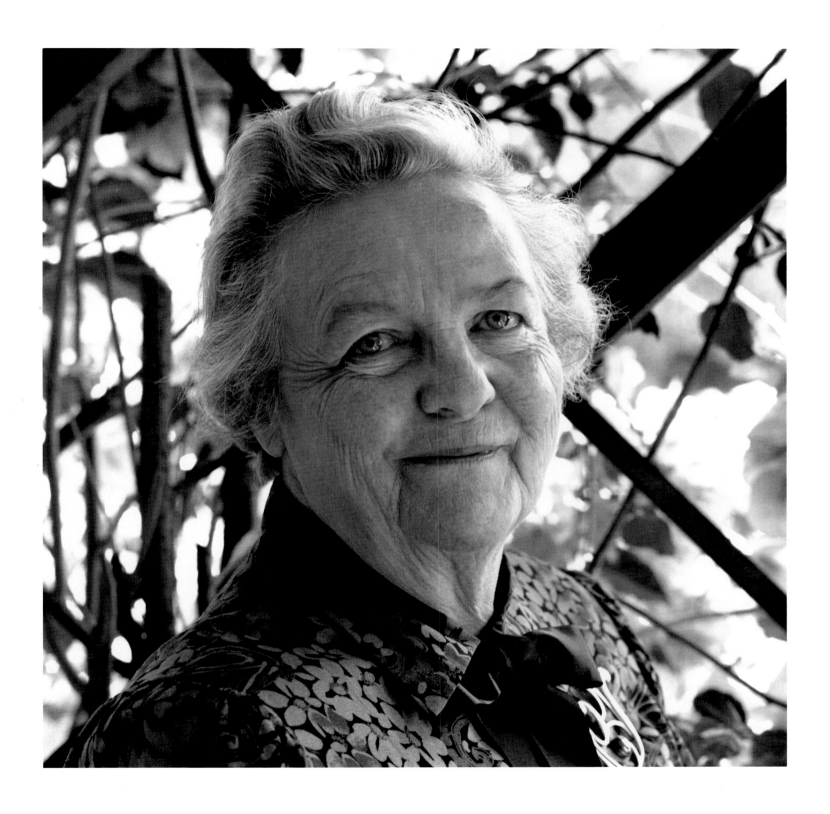

JEAN SHINODA BOLEN, MD

Jungian Analyst/Author

Dr. Bolen is a psychiatrist and Jungian Analyst in private practice in San Francisco. She is also a Clinical Professor of Psychiatry at the University of California Medical Center, faculty member of the San Francisco C.G. Jung Institute, and author of three internationally known books in the field:

Goddesses in Everywoman

Gods in Everyman

The Tao of Psychology

She has also written:

Ring of Power: The Abandoned Child, The Authoritarian Father, and the Disempowered Feminine

The Grail and the Goddess.

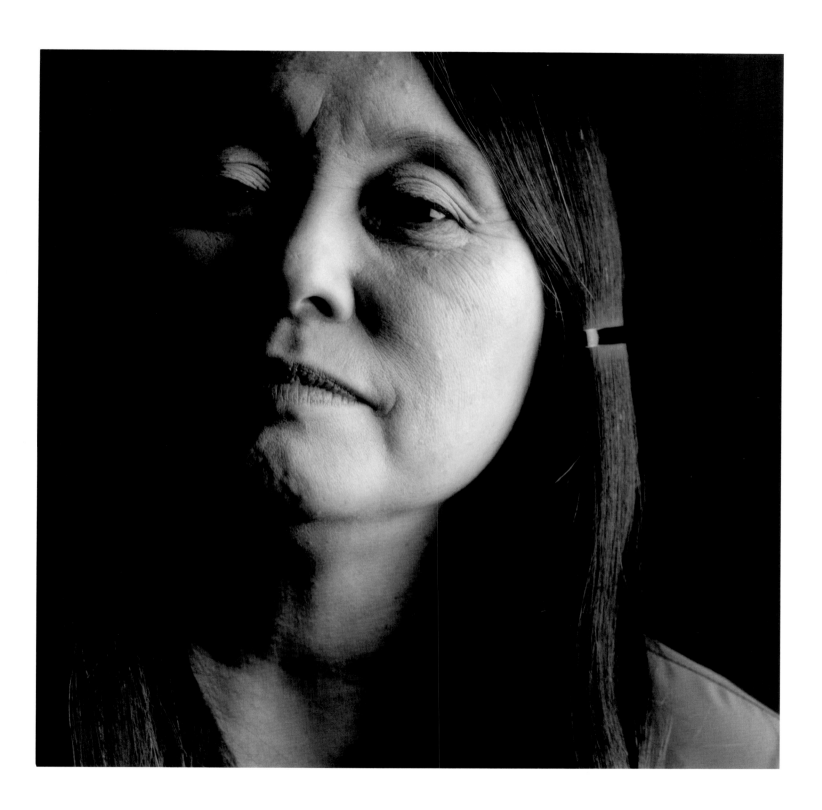

ELIZABETH TERWILLIGER

Naturalist/Environmentalist

Elizabeth Terwilliger pioneered environmental education in Marin County, California. Her work with school children for over 40 years inspired the formation of the Terwilliger Nature Education Center which has trained over 400 volunteer naturalists in her methodology and her mission — to teach all children an awareness and appreciation of nature. Terwilliger Nature Guides now reach over 65,000 school children each year.

Now in her 80's, she still spends the bulk of her time teaching children about the outdoors in the outdoors. She was a founding member of the Audubon Society's planning commission and she was instrumental in the creation of bicycle and nature trails, a Monarch butterfly preserve, several salt water marshes and playgrounds in California. She was instrumental in acquiring 700 acres of private land for a wildlife sanctuary; she is also responsible for starting the Outdoor Education program in Marin County Schools.

Terwilliger has been honored as one of the Bay Area's "Ten Most Distinguished Citizens." In 1984 she received the President's Volunteer Action Award. Newsweek *magazine named her as one of 1988's American Heroes Award recipients.*

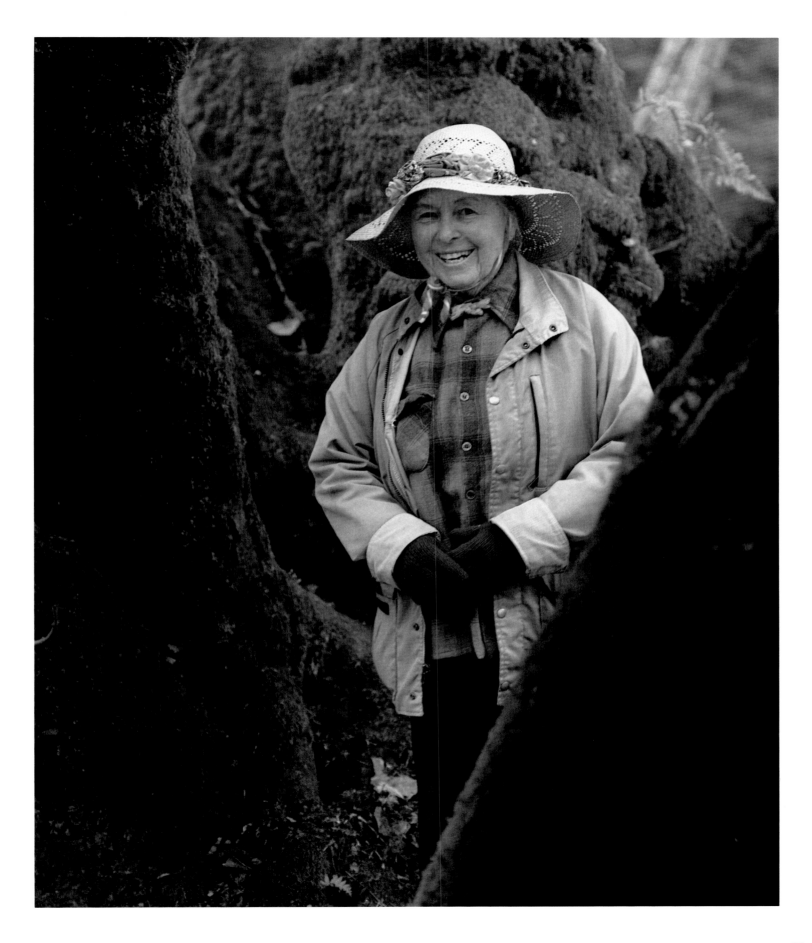

LONNIE BARBACH, PhD
Clinical Psychologist/Author

*Dr. Barbach is a clinical psychologist
and the author of numerous popular
books about the nature of the
relationship between men
and women:*

Going the Distance: Secrets to Lifelong Love
Erotic Interludes: Tales Told by Women
Pleasures: Women Write Erotica
The Intimate Male: Candid Discussions
About Women, Sex and Relationships
For Each Other: Sharing Sexual Intimacy
Shared Intimacies: Women's Sexual Experiences
Women Discover Orgasm: A Therapist's
Guide to a New Treatment Approach
For Yourself: The Fulfillment of Female Sexuality

*Her books have sold over
three million copies in English
and have also been translated into
French, German, Japanese, Italian,
Swedish, Dutch, and Hebrew.
Dr. Barbach has also produced
a number of video tapes:*

Falling in Love Again: A Sexual Enhancement Program
Sex After 50: A Guide to Lifelong Sexual Pleasure

*She is an Assistant Clinical
Professor of Psychology at the
University of California Medical
Center, Department of Psychiatry,
San Francisco.*

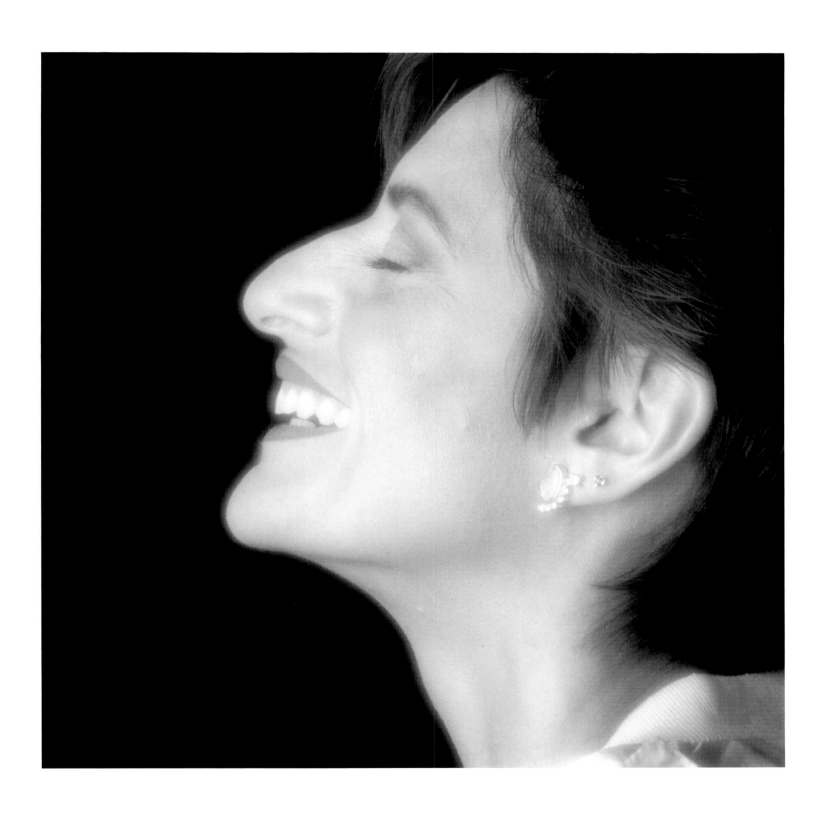

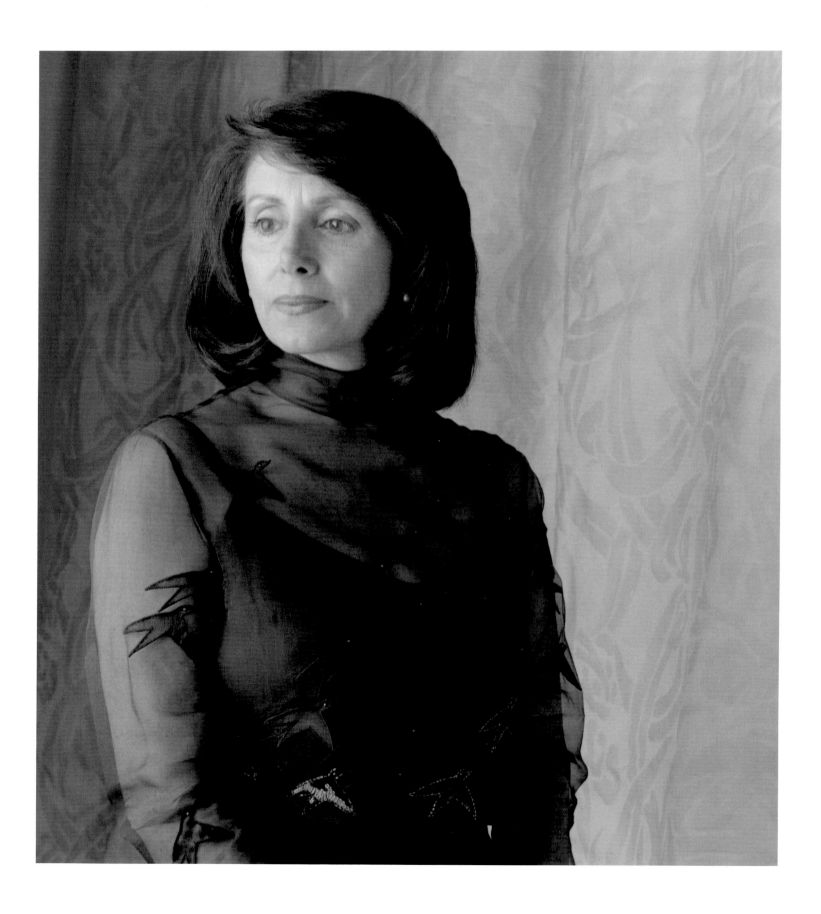

NANCY PELOSI
Congresswoman

Congresswoman from California's 5th District since 1987. Her prior experience includes serving as State Chair of the California Democratic Party. Pelosi has served on the House Banking, Finance and Urban Affairs Committee, the Government Operations Committee, the Executive Committee of the Congressional Caucus on Women's Issues, the Arms Control and Foreign Policy Caucus, the Black Caucus, the Hispanic Caucus and the Human Rights Caucus. In 1990 she was elected to the Executive Board of the Democratic Study Group and as the Northern California Democratic Whip.

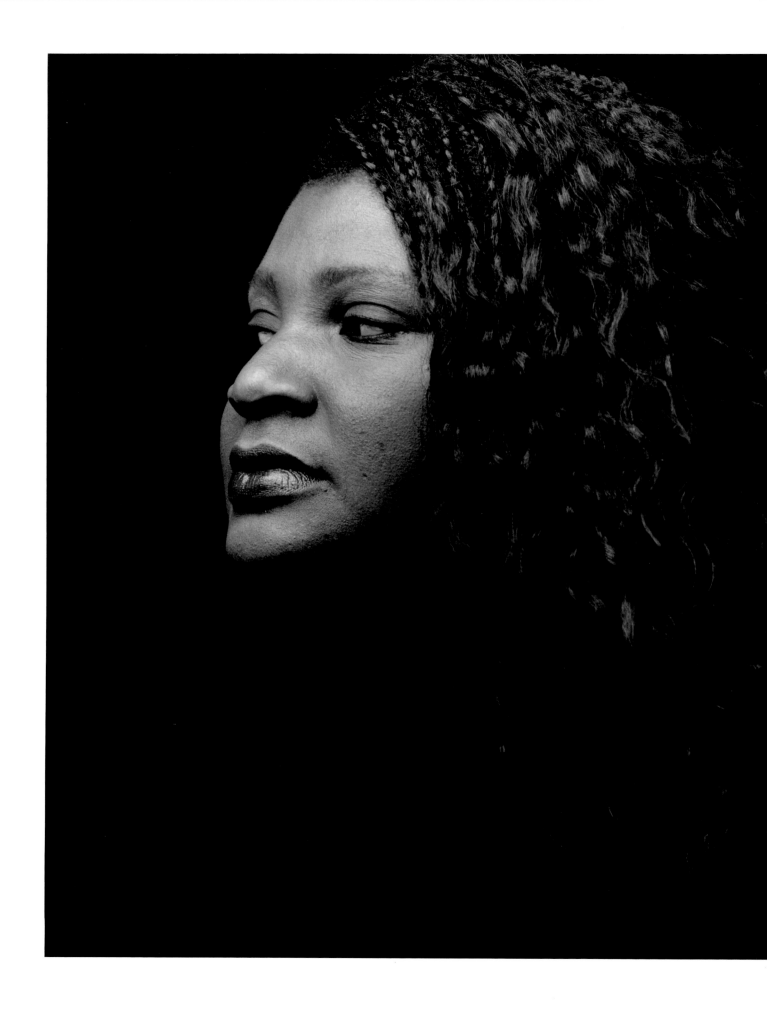

EVA PATERSON
Civil Rights Attorney

Executive Director of the San Francisco Lawyers' Committee for Urban Affairs. Her work in the reform of laws for the arrest and prosecution of wife batterers has been precedent-setting. She is nationally known for her work as Lead Counsel in the San Francisco Firefighters case, a Title VII employment discrimination case brought on behalf of women and minorities in order to desegregate the San Francisco Fire Department. Ms. Paterson chairs the Bay Area Coalition for Civil Rights and is a civil rights activist.

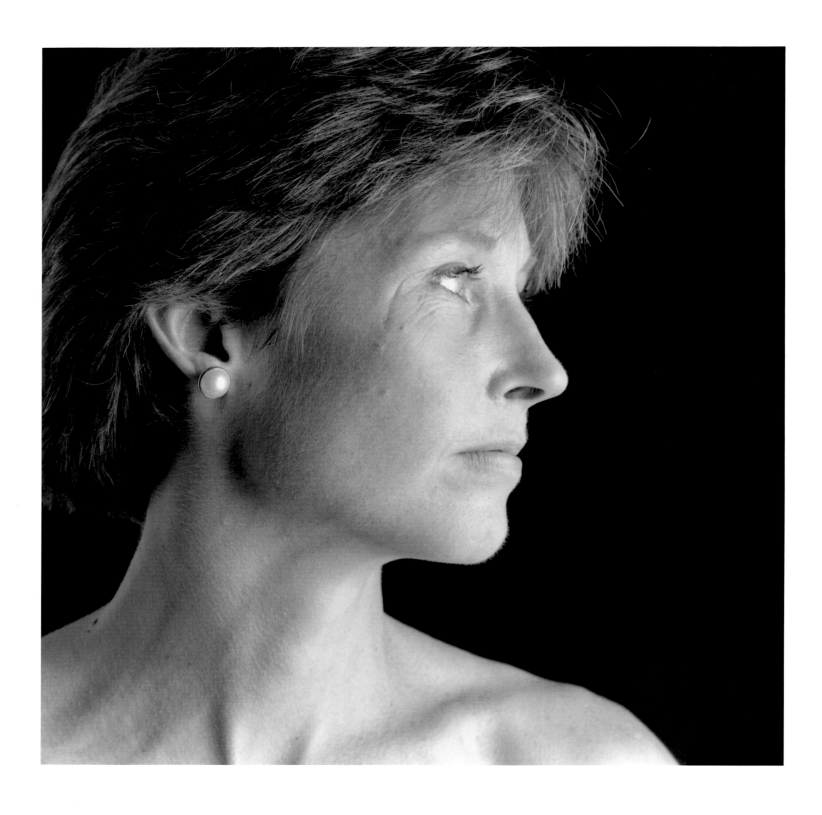

NANCY DITZ
Marathon Runner

Nancy Ditz was a member of the 1988 U.S. Olympic Marathon Team. She was the top-ranked U.S. Marathoner in 1987 (Track and Field News). *She is the winner of numerous marathons:*

San Francisco Marathon Champion, 1982

First American Woman,
1983 New York City Marathon

Oakland Marathon Champion, 1983

First American Woman, 1985 World Cup
Marathon, Hiroshima, Japan

U.S. National Marathon Champion, 1985

Los Angeles Marathon Champion, 1986, 1987

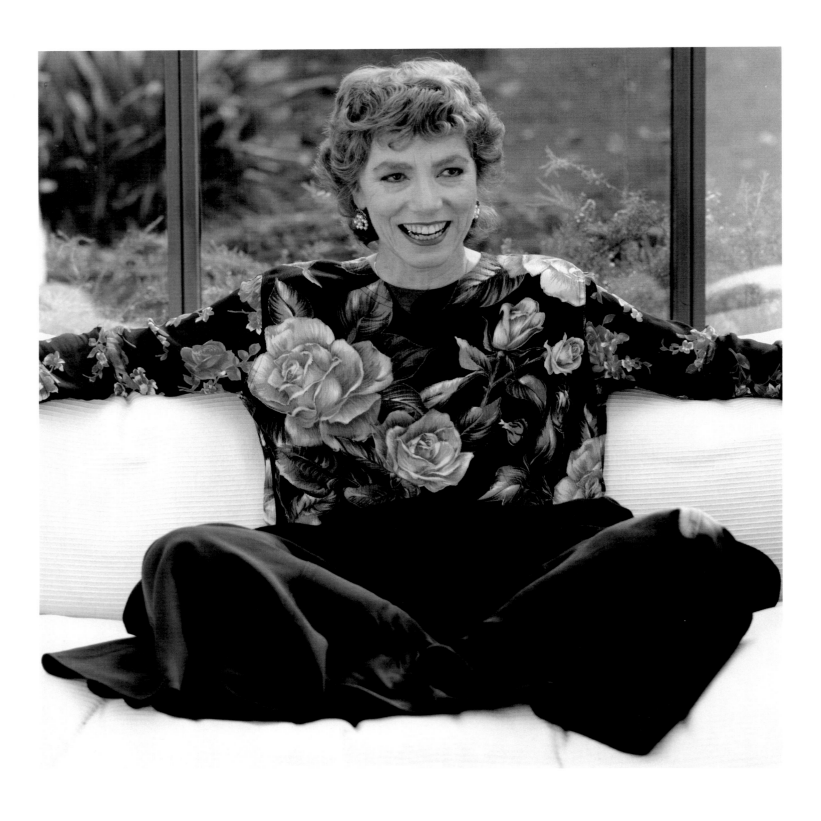

BARBARA BABCOCK

Professor of Law/Stanford University

*Barbara Babcock is the Ernest W.
McFarland Professor of Law at
Stanford University Law School,
where she teaches Civil Procedure
and Criminal Procedure. A Yale law
school graduate, Babcock practiced
criminal defense law in the District
of Columbia for almost ten years,
four of those as Director of the
Public Defender Service. She joined
the Stanford faculty in 1972 as its
first woman professor. In her early
years at Stanford, she taught and
wrote in the newly emerging field
of sex discrimination law. On leave
from Stanford University Law
School, she served as Assistant
Attorney General in the Civil Rights
Division in the Department
of Justice during the Carter
administration. In addition, her
interests have drawn her to write a
biography of Clara Shortridge Foltz,
the first woman lawyer on the
Pacific Coast and the founder of the
public defender movement.*

JOY CARLIN
Director/Actor

Joy Carlin is an associate Artistic Director of the American Conservatory Theater (ACT), as well as a member of the acting company. Among the many roles she has played are:

Kitty Duval in The Time of Your Life
Bananas in The House of Blue Leaves
Asa in Peer Gynt
Birdie in The Little Foxes
Enid in The Floating Light Bulb
Ranevskaya in The Cherry Orchard
Lady Wishfort in The Way of the World
Amanda in The Glass Menagerie
Big Mama in Cat on a Hot Tin Roof

She has also worked as the Resident Director of the Berkeley Repertory Company and served as its Acting Artistic Director. Among her directing credits are:

The House of Bernarda Alba
The Lady's Not for Burning
Marco Millions
Golden Boy
Awake and Sing
Hapgood

This portrait of her was taken on the set of Hapgood. *She has also directed at the Oregon Shakespeare Festival, The San Jose Repertory Co., A Contemporary Theater of Seattle and in China at the Shanghai Youth Drama Troupe where she directed* You Can't Take It With You.

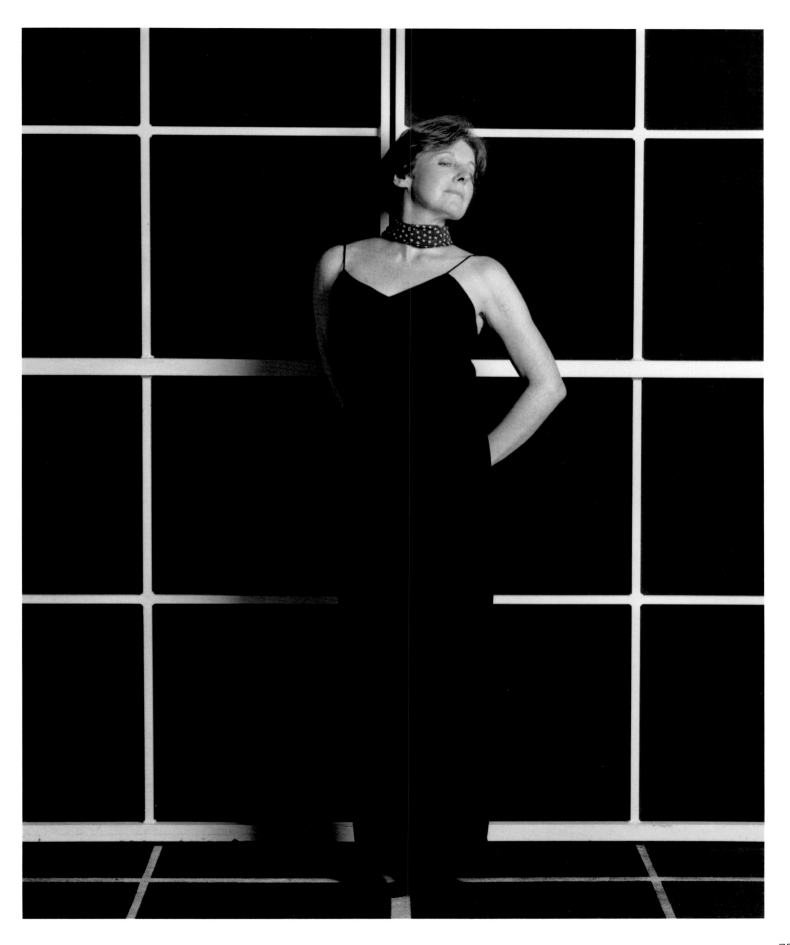

JUDITH HEUMANN

Disabled Rights Activist

Judith Heumann is an activist and champion for the rights of disabled people and Co-Founder of the World Institute on Disability. From 1975–82 she was the Senior Deputy Director of the Center for Independent Living, the nation's prototype center for independent living. Heumann is Chairperson of Disability International-USA, Assistant National Secretary for the U.S. Council on International Rehabilitation, and a member of the Board of Directors of the National Council on Independent Living.

During her career, she has been a Presidential Appointee to the National Council on Disability, has served on the President's Committee on Employment of Persons with Disabilities and on the Commission on the Status of Women. She has written extensively and lectured all over the world on issues of independence for disabled people. She has received numerous honors including the first Henry B. Betts Award for her efforts that significantly improved the quality of life for people with disabilities.

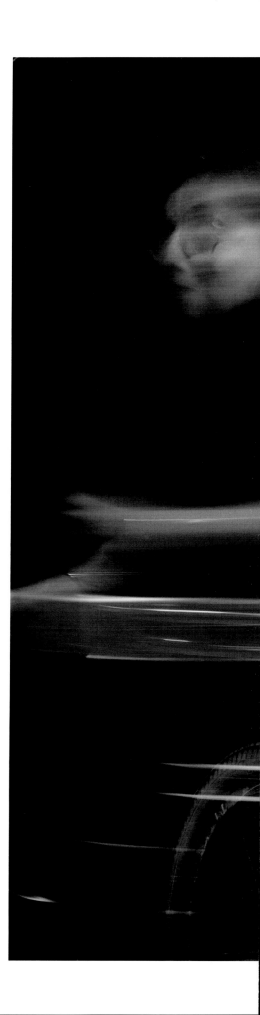

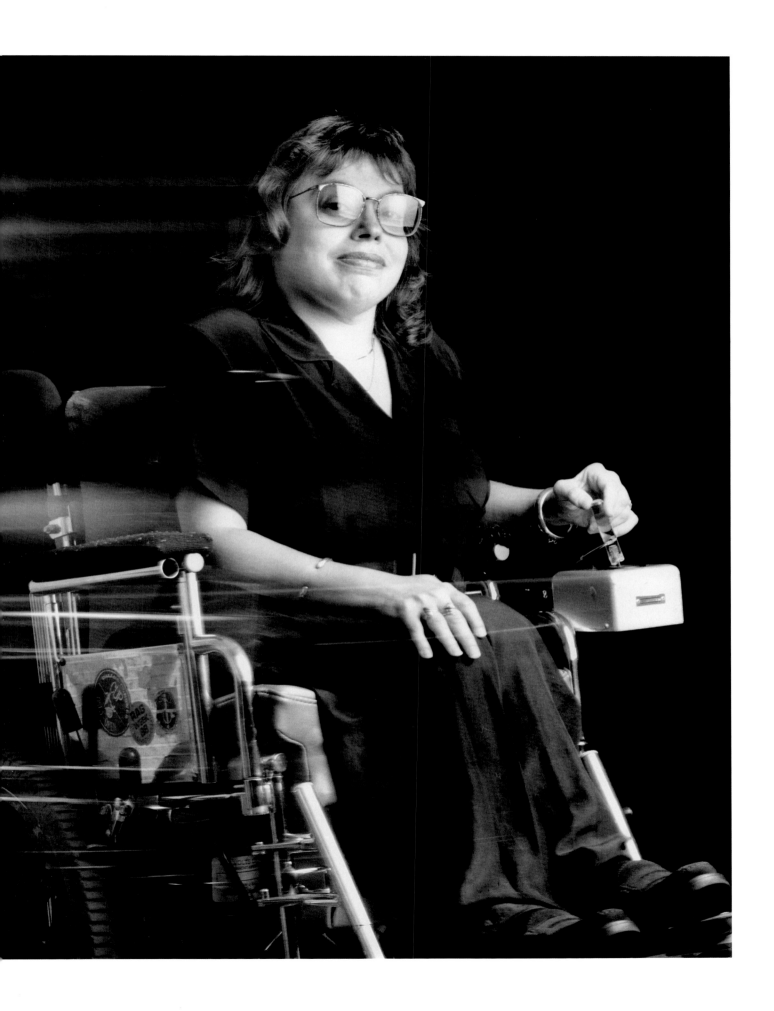

JESSICA McCLINTOCK
Clothing Designer

Founder, owner, designer of Jessica McClintock Inc. Since 1969, when she invested $5000 and took over a company called "Gunne Sax," Jessica McClintock has built a company that grew to sales of over $100 million in 1987. This company is driven by the style and vision of its owner who has carved a unique niche in the manufacture and retailing of ready-to-wear clothing. McClintock does all the designing herself.

There are currently ten Jessica McClintock stores throughout the United States. Her designs are also carried in major retail stores in the United States, Canada, Scotland, Iceland, Norway, West Germany and Britain. She won the 1986 Tommy Award for design as well as the Golden Shears Award.

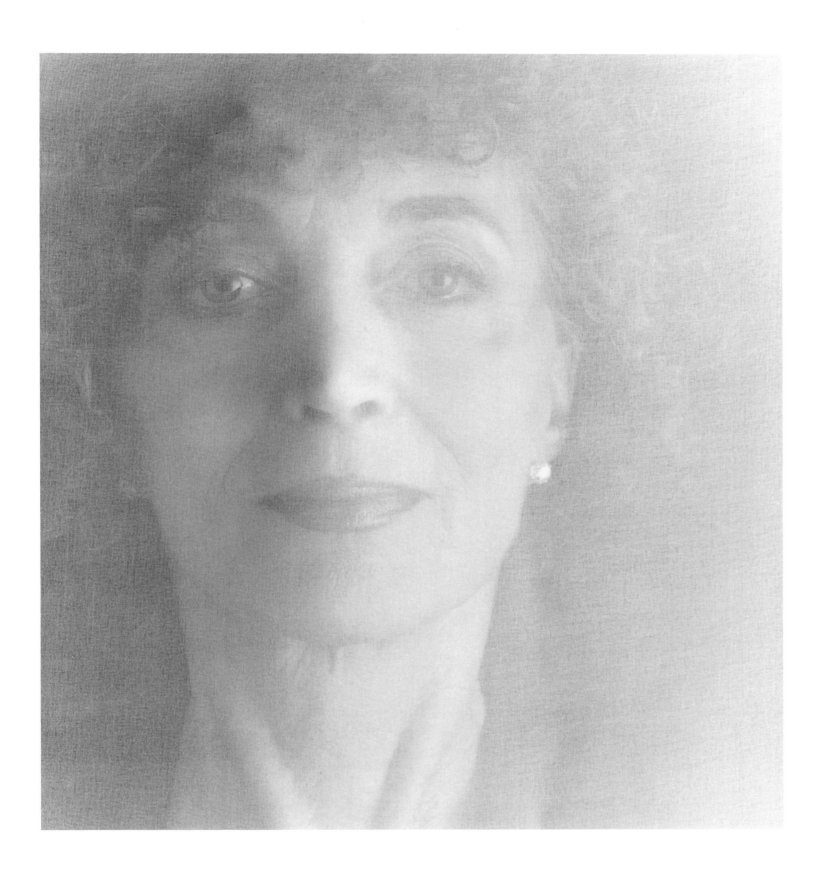

AILEEN HERNANDEZ
Urban Affairs Consultant

Ms. Hernandez is the President and Founder of an urban consulting firm working with major American companies, government agencies, educational institutions, foundations and community groups in the areas of human relations, equal employment opportunity, affirmative action, fair housing and transportation planning. In the early 1950's, Hernandez worked as an organizer in the International Ladies' Garment Workers' Union. After serving for three years as the Assistant Chief of the California Division of Fair Employment Practices, she was appointed by President Johnson in 1965 as the only woman member of the first United States Equal Employment Opportunity Commission. She was the second President of the National Organization of Women and a founding member of Black Women Organized for Action and Bay Area Black Women United.

Ms. Hernandez served for ten years as a Board member of the Ms. Foundation for Women and is a Life Trustee of the Urban Institute and the Rand Corporation's Institute for Civil Justice. As co-chair of the National Urban Coalition and Chair of the Board of Working Assets, she has worked on economic development issues for the disadvantaged. She has been honored by the Southern California Community Relations Conference as Woman of the Year; by the San Francisco Examiner *as one of the Ten Most Distinguished Women in the San Francisco Bay Area; by Howard University for Distinguished Postgraduate Achievement in the Fields of Labor and Public Service; by the Center for Women Policy Studies as a recipient of the Jessie Bernard Wise Woman Award; and by the American Civil Liberties Union with the Earl Warren Civil Liberties Award.*

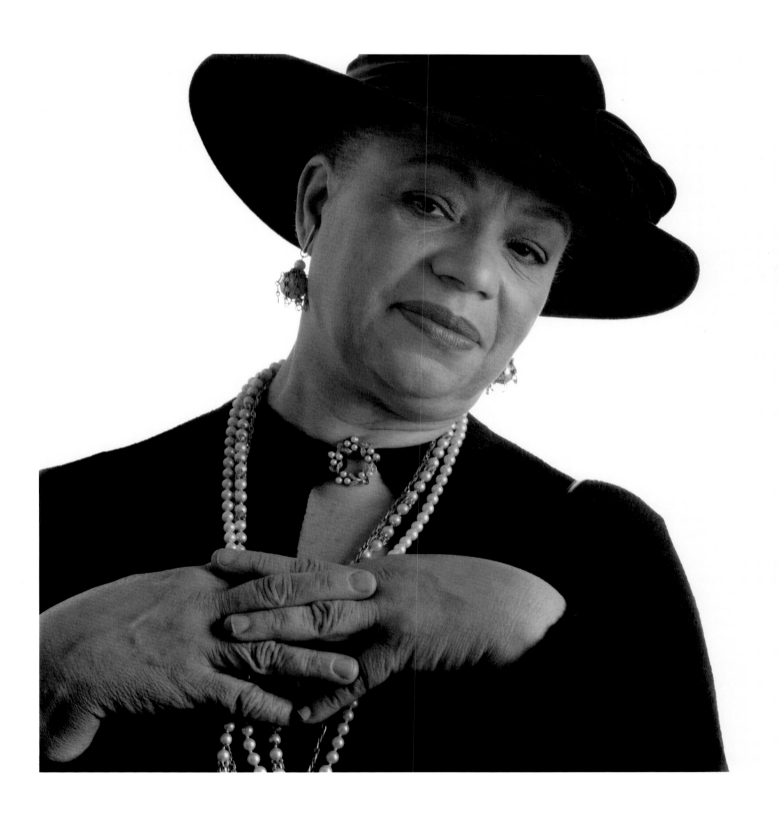

FRANCES MOORE LAPPÉ

Executive Director: Institute for Food and Development Policy

Ms. Lappé is the Co-founder and Co-director of the Institute for the Arts of Democracy and the author of the three-million copy best-selling book, Diet for a Small Planet. *Her research on the causes of hunger have resulted in the publication of eight additional books:*

Food First: Beyond the Myth of Scarcity, 1979

Aid as Obstacle: Twenty Questions on Our Foreign Aid and the Hungry, 1980

Now We Can Speak, 1983

What to Do After You Turn Off the TV, 1985

World Hunger: Twelve Myths,1986

Betraying the National Interest, 1987

Rediscovering America's Values, 1989

Taking Population Seriously, 1990

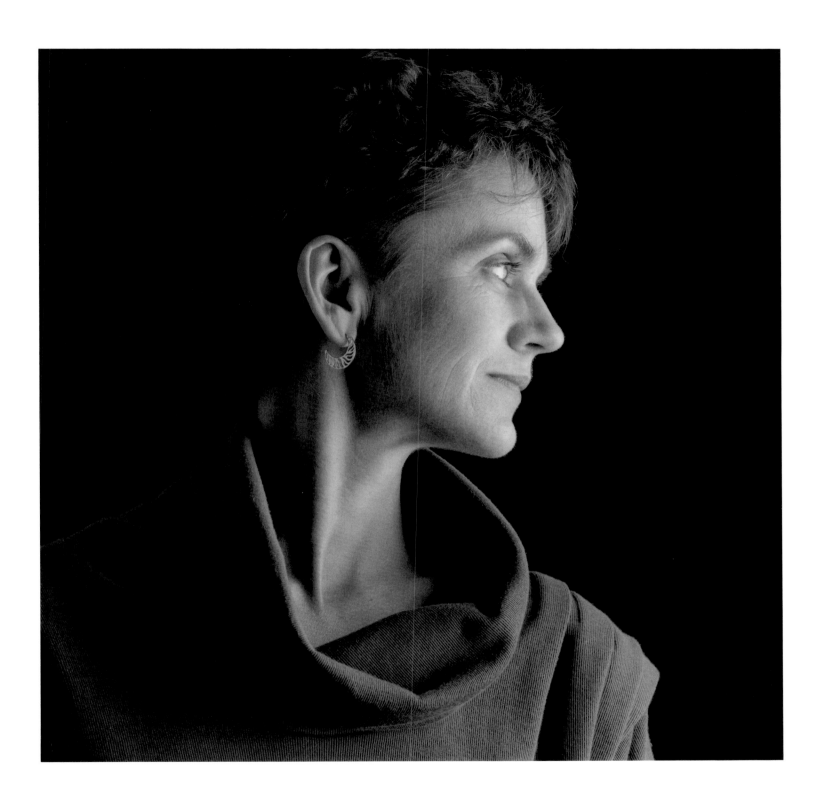

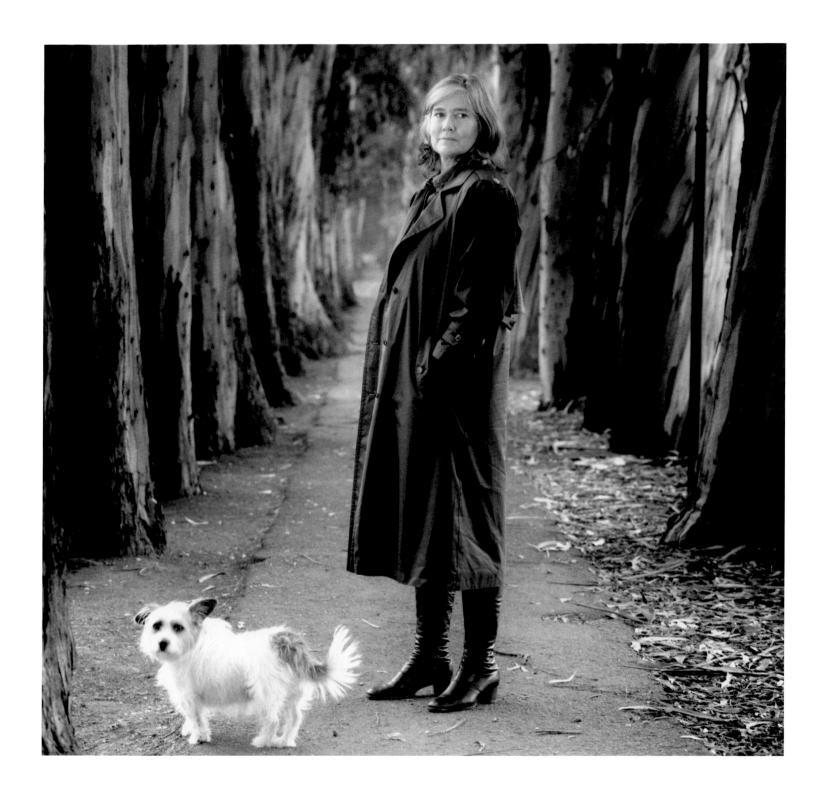

DIANA E. H. RUSSELL, PhD
Social Psychologist/Author

Dr. Diana E. H. Russell was a Full Professor at Mills College in Oakland, where she taught sociology and women's studies for 22 years before resigning in June 1991. She is an internationally renowned expert on sexual violence and is the author of twelve books, most of which deal with sexual violence toward women. She has also published books on the anti-apartheid struggle in South Africa, and on feminist perspectives on the threat of nuclear war. Her books include:

The Politics of Rape, 1975

Rape in Marriage, 1982 (revised in 1990)

Sexual Exploitation: Rape, Child Sexual Abuse, and Workplace Harassment, 1984

Secret Trauma: Incest in the Lives of Girls and Women, 1986

Lives of Courage: Women for a New South Africa, 1989

Exposing Nuclear Fallacies, 1989

Femicide: The Politics of Woman Killing, 1992

Making Violence Sexy, 1992

Men Killing Women: Personal Stories

Born and raised in South Africa, she joined the anti-apartheid movement in the 1960's, including joining an underground revolutionary group, the African Resistance Movement. She has been arrested for her political activities in South Africa, Britain and the United States. Russell obtained a postgraduate diploma in Social Science and Administration from the London School of Economics and Political Science and her M.A. and Ph.D. from Harvard University. She has lectured throughout the United States and in many other countries. Dr. Russell has received numerous awards, including the 1986 C. Wright Mills Award, the most prestigious award in sociology, for her book on incest. She also received the 1988 Pioneer Award from the state of California for her outstanding contributions to the promotion of improved victim services.

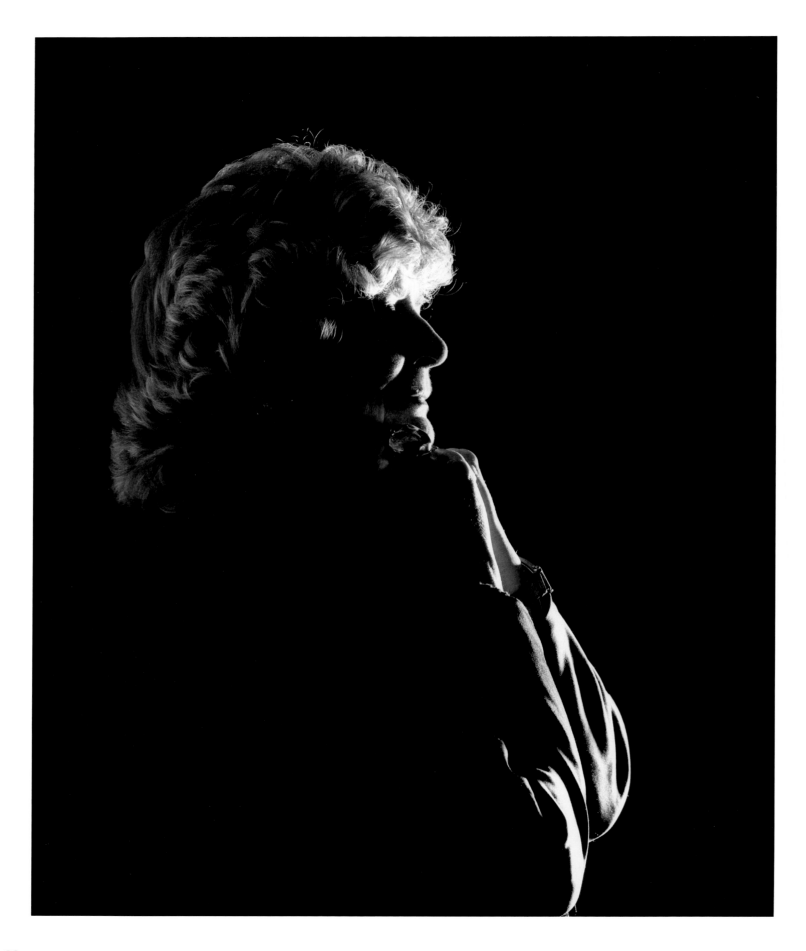

CAROLYN KIZER

Poet

Author of seven books of poetry
for which she has won
numerous awards:

The Ungrateful Garden, 1960
Knock Upon Silence, 1965
Midnight Was My Cry, 1971
YIN: New Poems, 1984
Mermaids in the Basement, 1984
The Nearness of You, 1986
Carrying Over, 1988

Governor's Award for the best book of the year,
State of Washington, 1965 and 1985
Pulitzer Prize for Poetry: 1985
Masefield Prize, Poetry Society of America, 1985
Award from the American Academy of Arts and Letters, 1985
Award of Honor, San Francisco Arts Commission, 1986
Frost Medal, The Poetry Society of America, 1988

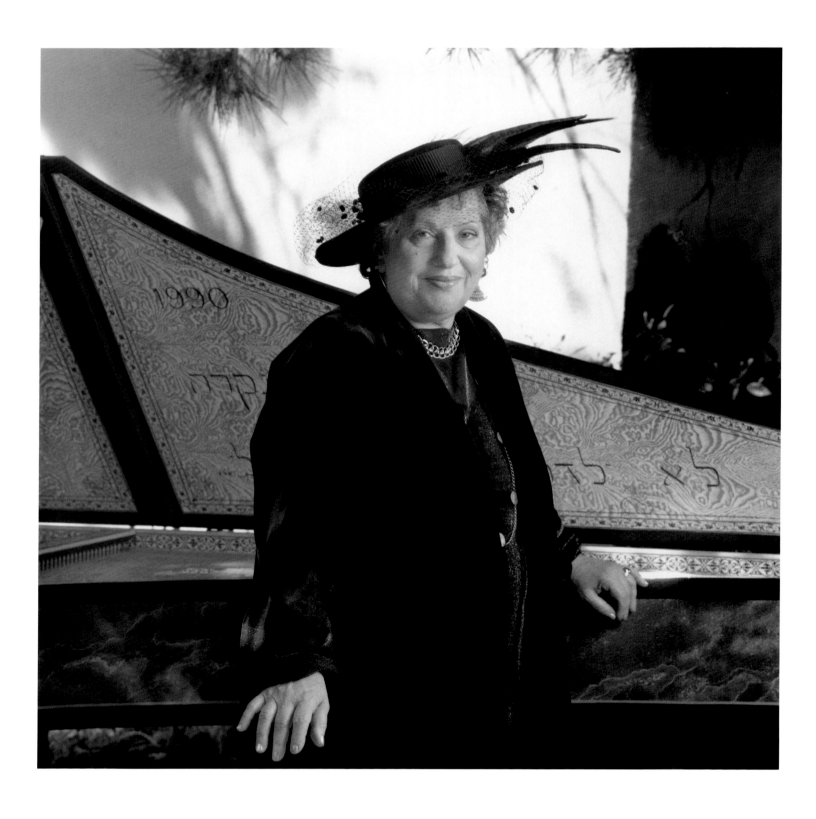

LAURETTE GOLDBERG

Classical Musician

Laurette Goldberg is a renowned harpsichordist and the founder of MusicSources. Her work as both an educator and a performer has given her an international reputation in the world of historical performance in general and Baroque music in particular. She is the founder of the San Francisco based Philharmonia Baroque Orchestra, a major international recording and touring institution.

Ms. Goldberg teaches at the University of California, Berkeley and the San Francisco Conservatory of Music where she began and still chairs the Baroque program; she served as founding board member of Early Music America — America's professional organization for period performance — and was Music Director of the Junior Bach Festival Association. She has performed in the United States, Denmark, Australia, Canada, Europe and Israel. She has recorded for the 1750 Arch Street *and* Harmonia Mundi *labels and has written an edition of Bach's preludes and fugues,* J.S. Bach Open Score, The Well-Tempered Clavier.

LAUREL BURCH
Artist/Designer/Entrepreneur

Laurel Burch began designing jewelry to sell on the streets of the Haight-Ashbury in the 1960's as a single mother of two. Today she is sole owner of a company which had over $10 million in sales in 1988. The company has two retail stores, in Sausalito and in Carmel, California. The company's wholesale division is comprised of manufacturers on three continents which supply the merchandise for the over 1000 designs in the Burch collection sold by over 2500 retailers worldwide.

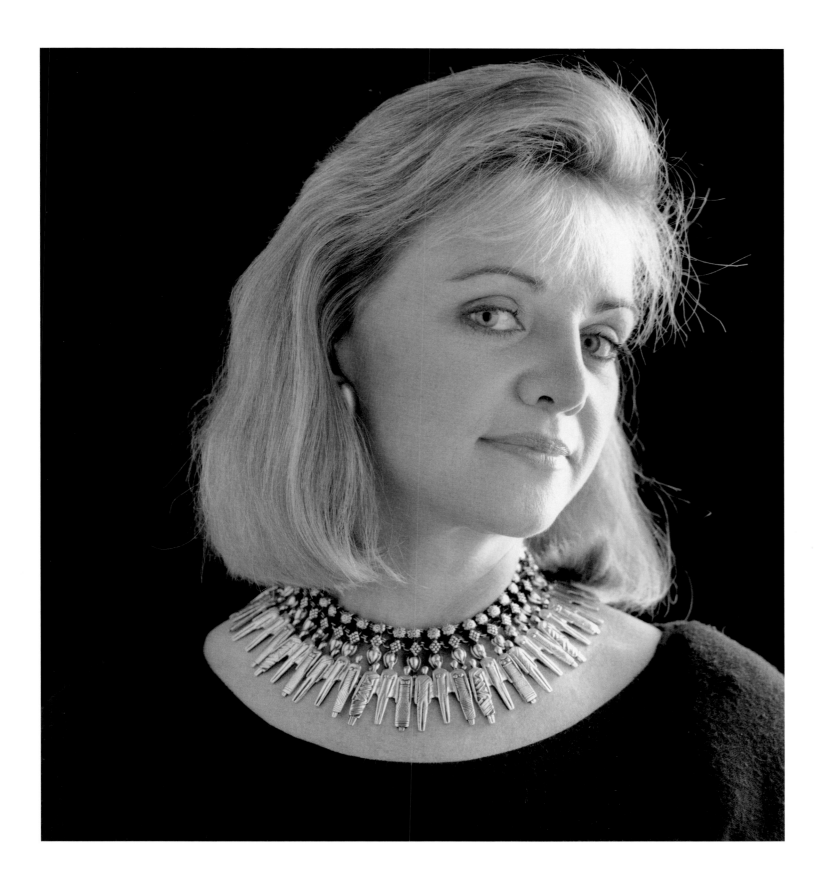

JUDITH NELSON

Classical Soprano

*Nelson is a performing
and recording artist who is
internationally acknowledged as
one of the world's leading singers
of the baroque repertoire. She has
performed throughout Europe and
the United States in concerts and
operas, as well as for radio and
television. She has sung with most
of the major baroque orchestras
on both continents, including
the* Academy of Ancient Music
(England), Tafelmusik *(Toronto),
and* Philharmonia *(San Francisco).*

*Nelson has performed with the San
Francisco, St. Louis, Baltimore, and
Washington National Symphony
Orchestras, and the Los Angeles
Philharmonic. She has appeared
in operas in Boston, Los Angeles,
Brussels, Innsbruck, Venice, Turin,
and Rome and she has over sixty
recordings to her credit. In 1989
she was awarded an honorary
Doctor of Fine Arts degree by her
Alma Mater, St. Olaf College,
Northfield, Minnesota.*

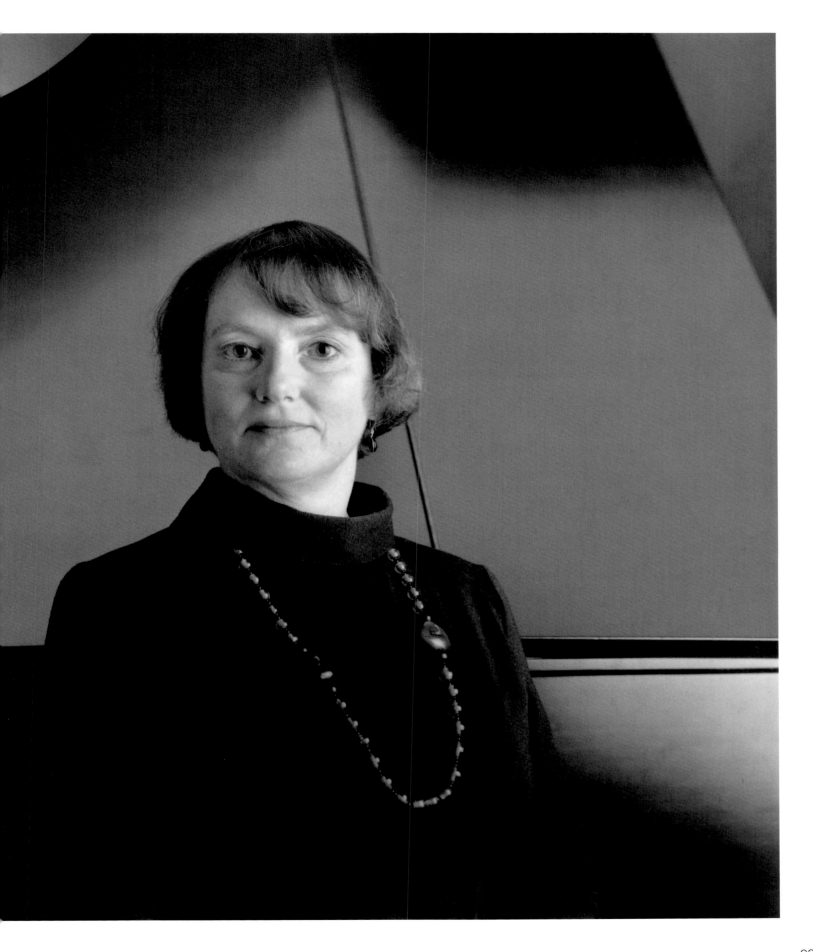

MAXINE HONG-KINGSTON

Author

Maxine Hong-Kingston is the author of several award-winning, best-selling books:

Woman Warrior: Memoirs of a Girlhood Among Ghosts
China Men
Hawai'i One Summer
Tripmaster Monkey—His Fake Book

She won the National Book Critics Circle Award for nonfiction for Woman Warrior, the National Book Award for nonfiction for China Men, *and the PEN USA West Award in Fiction for* Tripmaster Monkey— His Fake Book.

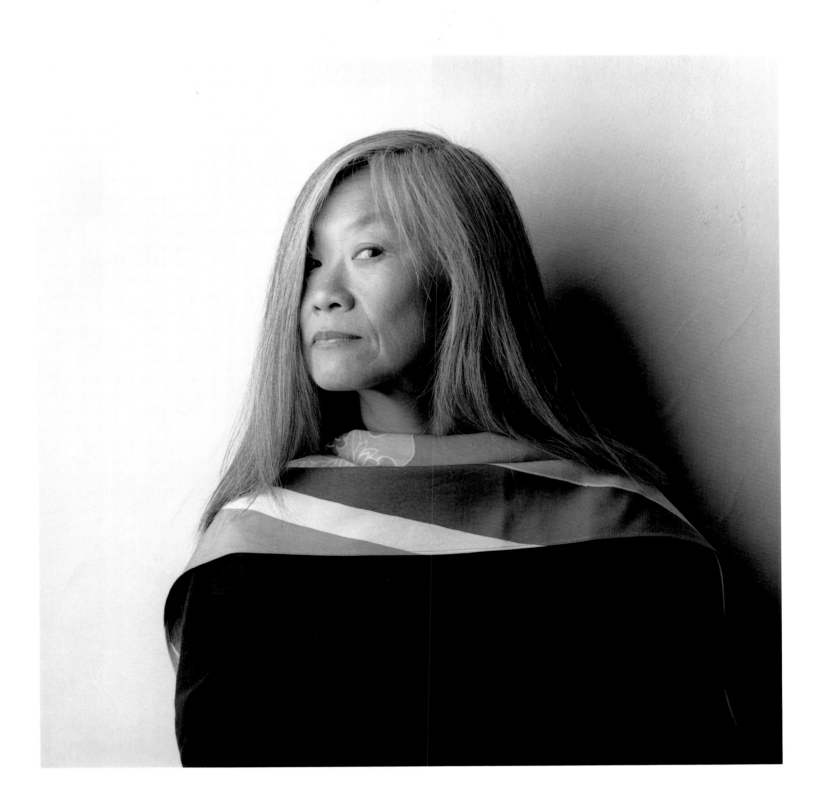

MIMI SILBERT, PhD

Executive Director: Delancey Street

Since 1973, Silbert has been the President/CEO of Delancey Street Foundation, a self-help residential treatment center for 700 ex-convicts, ex-addicts, and ex-prostitutes. The Foundation runs ten businesses and has facilities located in San Francisco, Los Angeles, New Mexico, New York and North Carolina. It is one of this country's most successful models for drug rehabilitation and post-parole transition for ex-convicts.

Silbert is the author of dozens of articles which focus on pornography, rape and sexual assault, prostitution, child sexual abuse, and state and community correctional facilities. She has served as a training consultant for the San Francisco Police Department, conducted over 100 training seminars on delinquency, crime, juvenile prostitution and drugs to groups such as the California State Juvenile Officer's Association, the State District Attorneys' Associations, and the American Psychological Association. She has served as a member of the Surgeon General's Commission on Pornography, the National Correctional Mediation Center and as director for dozens of criminal justice studies in California, New Mexico, New York and Washington, DC.

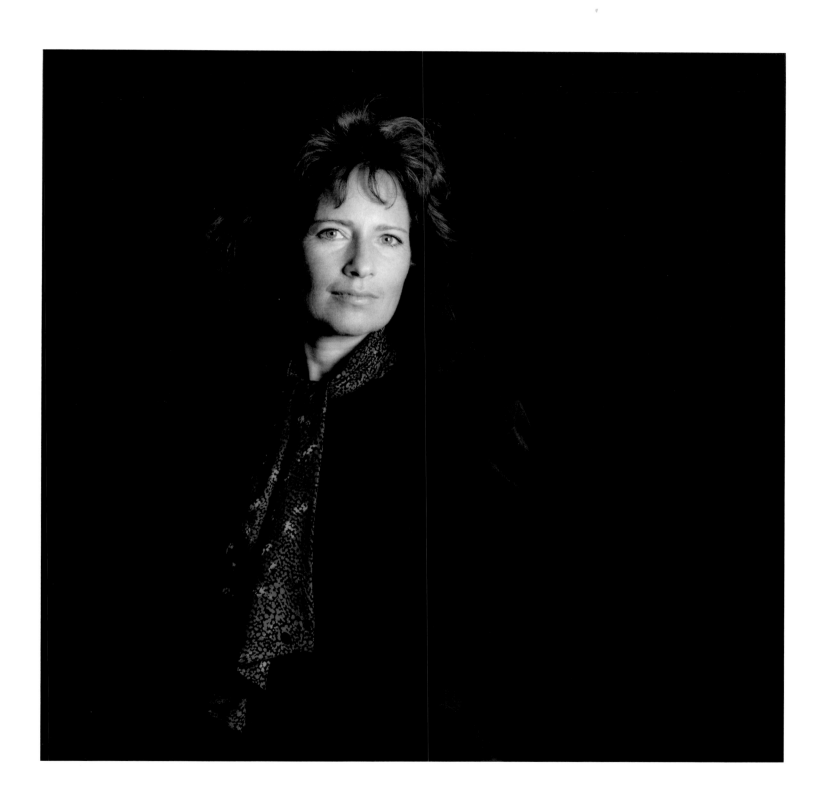

AMY McCOMBS

President, General Manager: KRON-TV

President and General Manager of KRON-TV, *Channel 4 in San Francisco since April, 1988. Prior to assuming her current position with* KRON, *McCombs was president and general manager of* WDIV-TV *in Detroit. Her career in broadcasting has included work as vice-president and general manager of* WJXT-TV *in Jacksonville, Florida; program manager at* WFSB-TV *in Hartford, Connecticut; and program manager of* WJXT-TV. *Her earlier career included work as a news reporter, anchor and promotion manager for* KOMU-TV *in Columbia, Missouri.*

McCombs was the first woman to serve on the NBC *Affiliate Board of Directors and she has served as a member of the National Association of Television Programming Executives. She has won numerous awards for her work in television including the 1990 Medal of Honor for "Distinguished Service in Journalism" from the University of Missouri School of Journalism; she was honored for her "outstanding contributions to broadcasting" by the San Francisco Chapter of American Women in Radio and Television in 1989; and in 1988 she received the National Headliner Award from Women in Communications.*

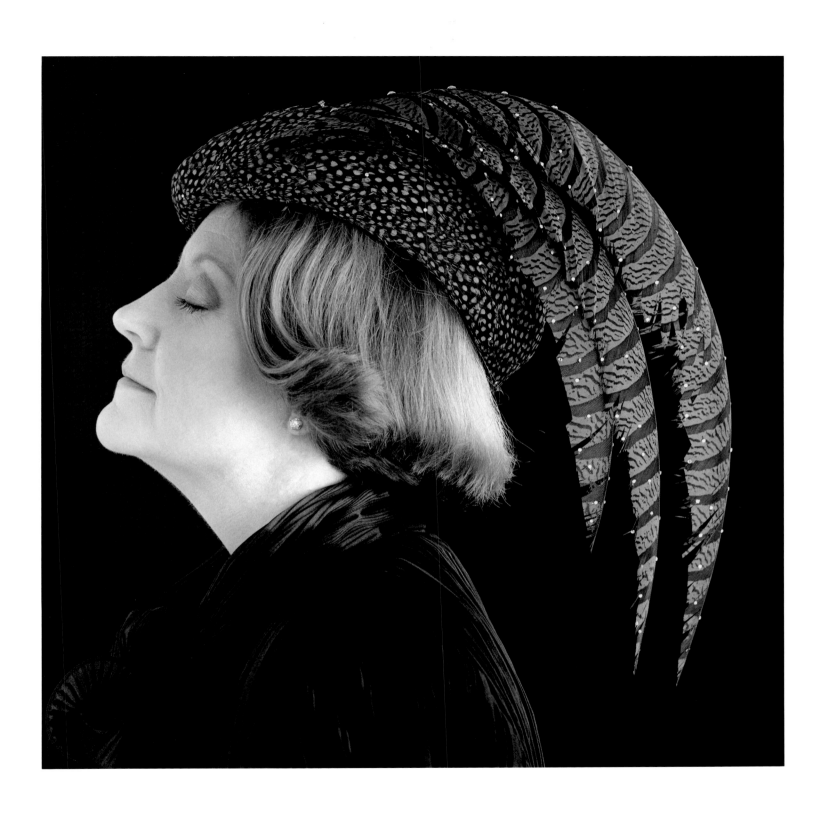

JEANNE ALLEN
Clothing Designer

Jeanne Allen is the co-owner, founder and clothing designer for Jeanne-Marc. She has been elected to the Council of Fashion Designers of America, the prestigious honorary society founded to further American fashion as a vital part of the world of art and culture. Her designs have been recognized by the Museum of Modern Art. The Jeanne-Marc factory in San Francisco manufactures and distributes all of the clothing to the company's 600 accounts across the country. There are Jeanne-Marc retail stores in San Francisco and New York.

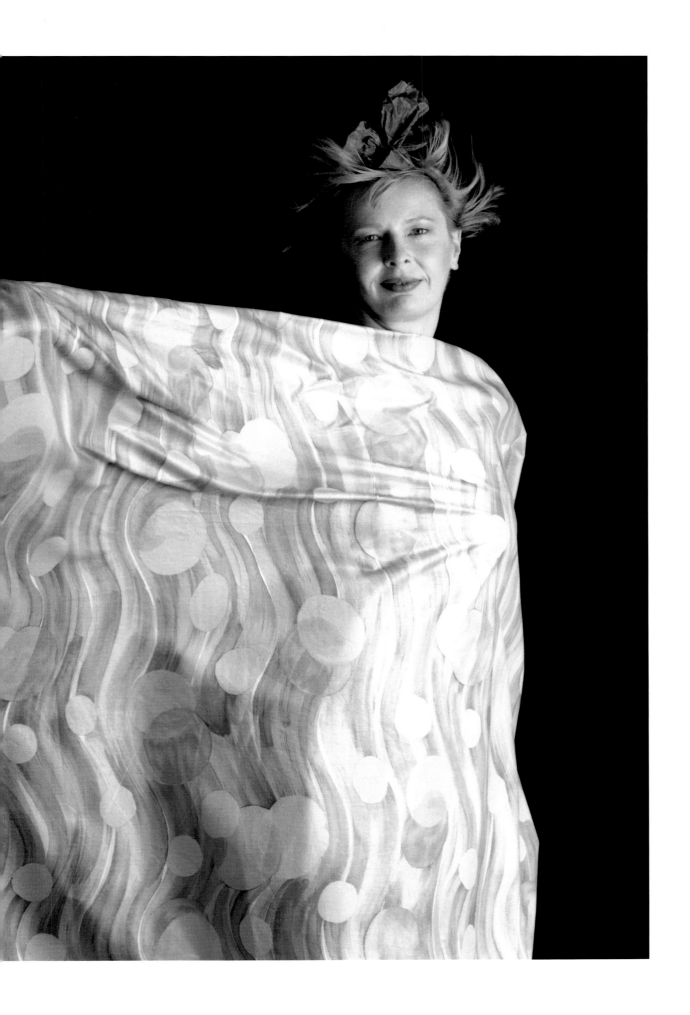

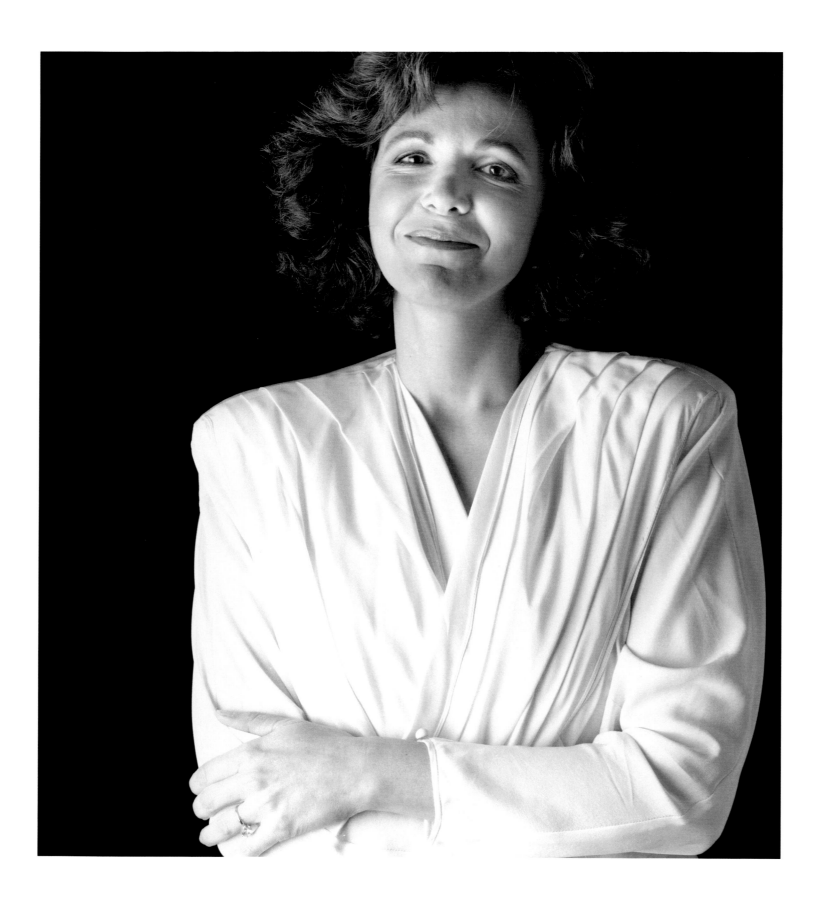

NANCY ASCHER, MD
Physician/Liver Transplant Specialist

Dr. Ascher is the first woman in the world to perform a liver transplant. She began research in transplantation immunology in 1976. In 1982 she initiated the liver transplant program at the University of Minnesota—one of only three centers performing this highly technical surgery at that time. In 1988, Dr. Ascher joined the faculty of the University of California Medical Center, San Francisco, to head a Division of Liver Transplantation.

She is nationally and internationally known for her work in transplantation rejection and served on the President's Task Force on Organ Transplantation in Washington, DC in 1985–1986. She has published over 250 articles in her field as well as numerous book chapters and editorials.

She serves on the American Board of Transplant Coordinators, The National Institutes of Health Task Force on Organ Transplantation, The National Institutes of Health Steering Committee of the Liver Transplant Database, and The National Institutes of Health Policy Board of the Liver Transplant Database. She has lectured all over the world on liver transplantation.

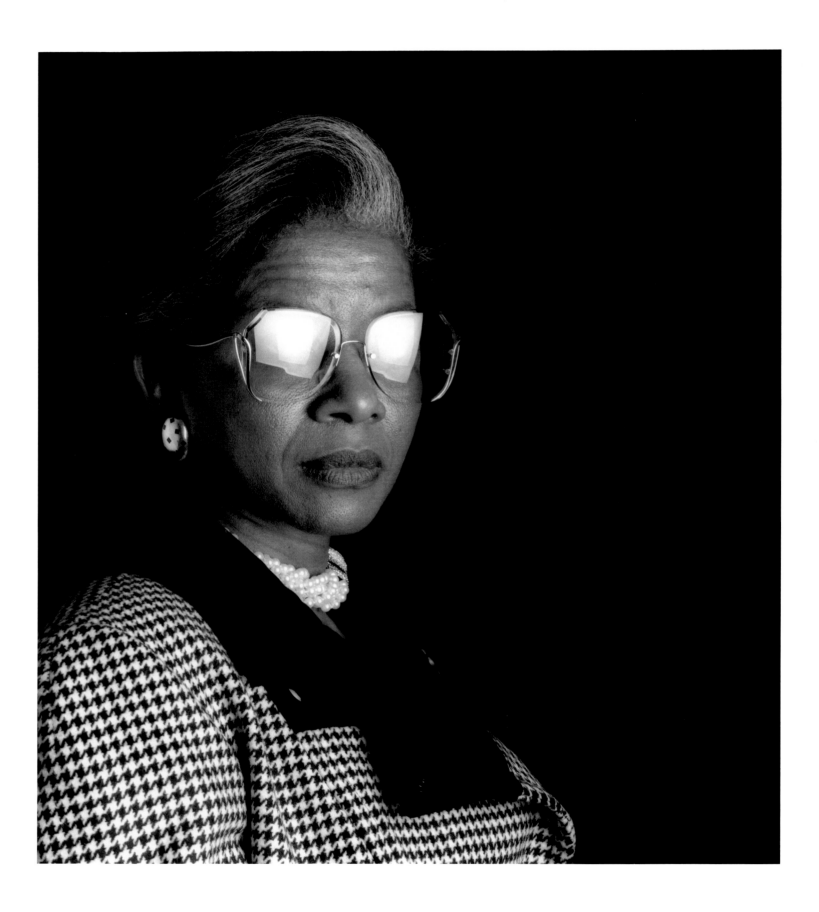

FRAN STREETS

Banker

Fran Streets began her banking career in 1966 at the Bank of California where she moved rapidly through the ranks to direct its Private Banking division. In 1985, she joined the Bank of San Francisco as First Vice President. In the fall of 1988, Ms. Streets was promoted to Senior Vice President.

She is involved in business and cultural activities, women's, minorities', and children's organizations. She has served as a Director of the San Francisco Education Fund and Edgewood Children's Center and as a trustee of the San Francisco Ballet. She is also an active board member of the Women's Campaign Fund. She is President of the Women's Forum and in 1989 she co-chaired the International Women's Forum Annual Conference; she also serves as Chair of the Merit Selection Panel to select magistrates for the United States District Court— Northern District of California.

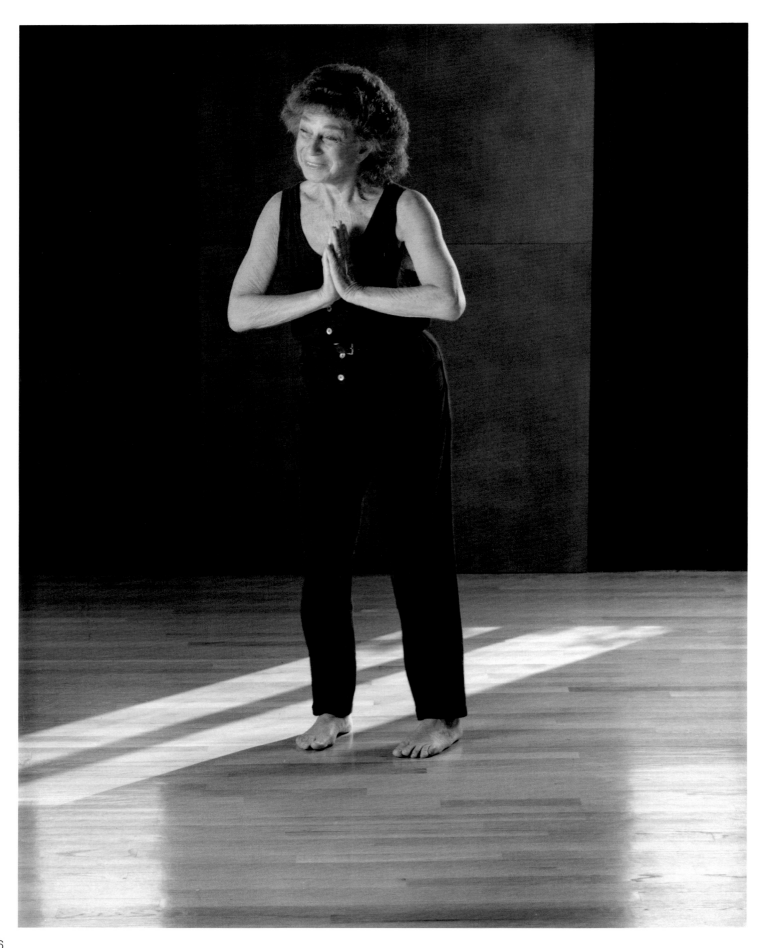

ANNA HALPRIN
Dancer/Choreographer

Anna Halprin founded the San Francisco Dancers' Workshop in 1955 and Tamalpa Institute in 1978. She is a seminal figure in American dance. Her work is noted for its focus on modern myths and rituals and for large scale public participation in both the creation and the performance of dances. Her community dance, "Circle the Earth" has toured the world.

Researching dance as a healing art, she currently directs "Moving Toward Life" for people challenging cancer, "Positive Motion" for men challenging AIDS/HIV, and "Women With Wings" for women with AIDS/HIV. She has led numerous international workshops for museums, universities, religious organizations and growth centers including the New York City Center, the Rubin Academy and Hebrew University in Israel, the Community Arts Center in London, Acrosanti in Arizona, and City Dances in San Francisco. She has published six volumes on her work, among them:

Movement Ritual
Dance as a Self-Healing Art
Circle the Earth Manual

Her work has been the subject of many films and videotapes including the Public Television special "Inner Landscapes—Lawrence and Anna Halprin." She has received numerous awards for her work including the 1980 Dance Guild Award for Outstanding Contributions to the Field of Dance; the Sustained Achievement Award from the Bay Area Isadora Duncan Hall of Fame; 1988 West Coast Outstanding Teacher of the Year Award; a Guggenheim Fellowship; and yearly Choreographer Fellowships from the National Endowment for the Arts.

CONDOLEEZZA RICE, PhD

Soviet Military Specialist, Stanford University

Specialist on Soviet and East European Politics, Foreign and Defense Policy and International Security Policy, serving as a Special Assistant to the President for National Security Affairs. Dr. Rice is Associate Professor of Political Science at Stanford University. Prior to that she was Senior Director for Soviet Affairs on the staff of the National Security Council.

From 1986–87 Dr. Rice served as Special Assistant to the Director of the Joint Chiefs of Staff assigned to Strategic Nuclear Policy. She is the author of The Soviet Union and the Czechoslovak Army, *and co-author of* The Gorbachev Era; *she has written numerous articles on Soviet and East European military policy.*

In 1984 Rice was awarded the Walter J. Gores Award for excellence in teaching at Stanford. She has been a Hoover Institution National Fellow and a Council on Foreign Relations Fellow and has served as a consultant to ABC *News on Soviet Affairs.*

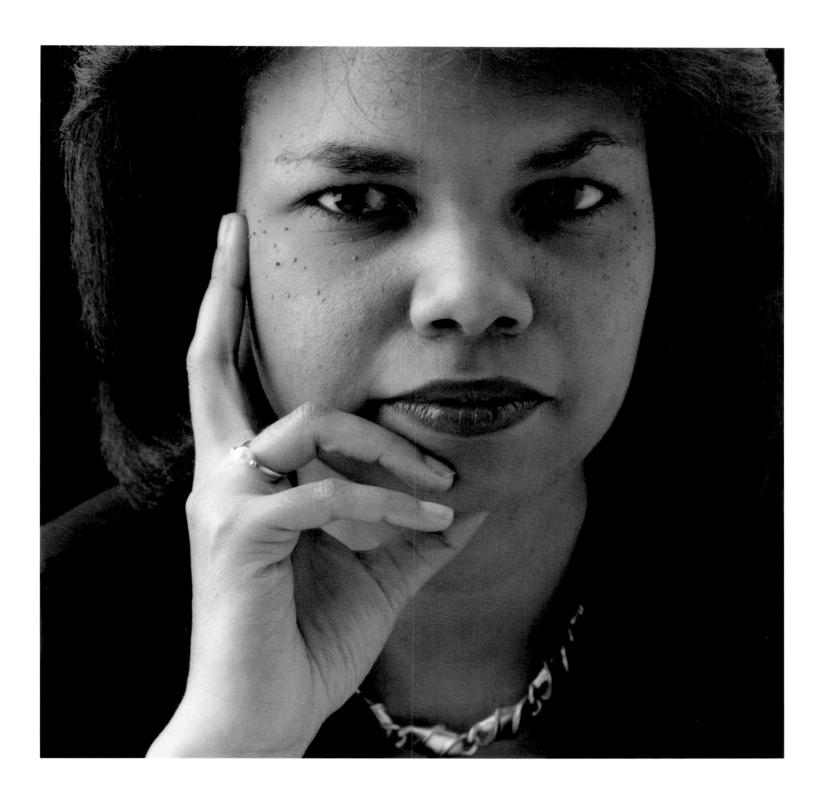

SYLVIA EARLE, PhD

Marine Scientist

Dr. Earle is a marine scientist, Fellow and Research Biologist at the California Academy of Sciences, and research associate at Harvard. She holds the world's record for the deepest dive by a human being without a tether to a boat. Called "Her Deepness" by colleagues, Earle recalls her historic 1979, 2½ hour walk on the ocean floor: "On the surface it was Hawaii high noon; but down a quarter mile, it was starry night."

In 1981, Dr. Earle co-founded Deep Ocean Technology, Inc., and in 1982, Deep Ocean Engineering, Inc., to design, develop, manufacture and operate equipment in the ocean and other remote hostile environments. She has served as President, Chief Executive Officer and Director of both companies. In 1990, Dr. Earle was appointed Chief Scientist of the National Oceanic and Atmospheric Administration.

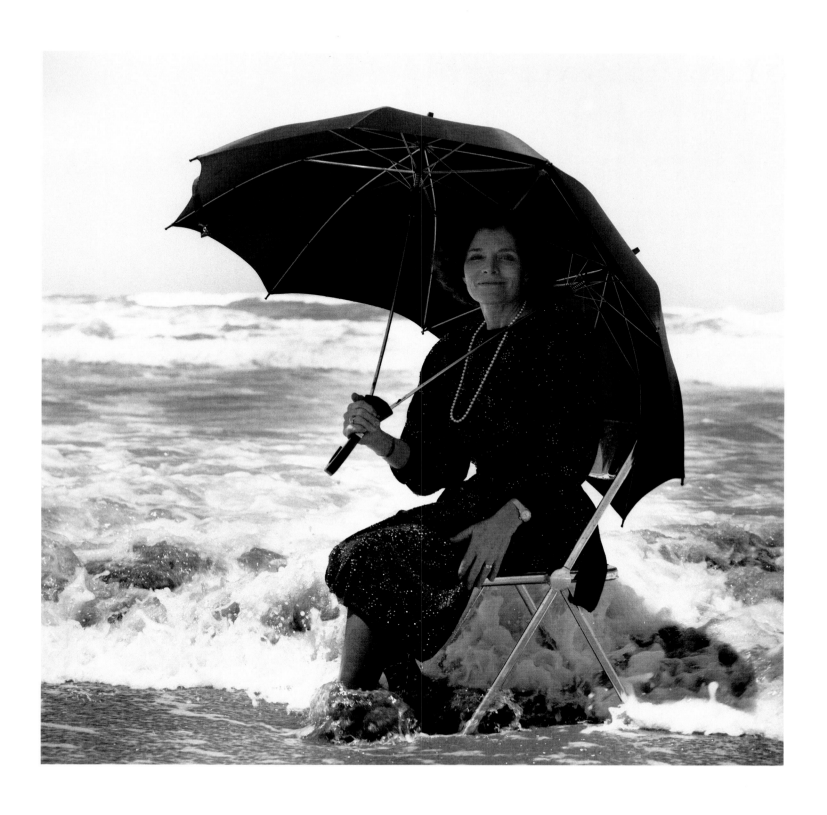

ALICE WATERS

Restaurateur

*Waters is a restaurateur and author
of four cookbooks. She opened
her world-famous restaurant,
Chez Panisse, in August 1971.
The set-menu format remains
to this day at the heart of Alice's
philosophy: to serve the highest
quality products according to
the season. A network of farmers
and ranchers, discovered and
encouraged over two decades, now
assures Chez Panisse of pure and
fresh ingredients. She also owns
and operates the upstairs Cafe
at Chez Panisse, opened in 1980
and Cafe Fanny opened in 1984.
Her publications include:*

Chez Panisse Menu Cookbook
Chez Panisse Pasta, Pizza and Calzone Cookbook
Chez Panisse Desserts
Chez Panisse Cooking

*She has received the James Beard
Special Achievement Award
(1985), Restaurant and Business
Leadership Award (1987),
Award of Honor in the Arts,
SF Art Commission (1987), Zonta
Woman of the Year Award (1989),
Barbara Boxer Top Ten Women
Award (1991), and City of Berkeley
Proclamation of Alice Waters Day
(1989).*

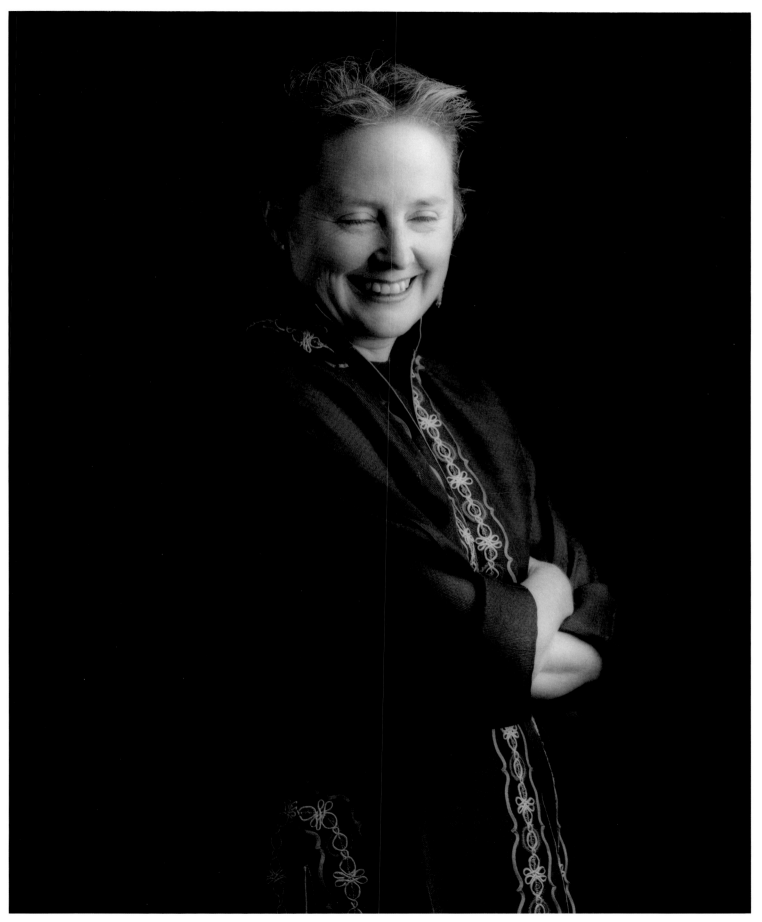

ISABEL ALLENDE

Author

World-renowned journalist, novelist, playwright and author of numerous short stories and children's stories:

The House of the Spirits, 1982
Of Love and Shadows, 1984
Eva Luna, 1987 (novel)
The Stories of Eva Luna, 1990 (short stories)
The Infinite Plan, 1992 (novel)

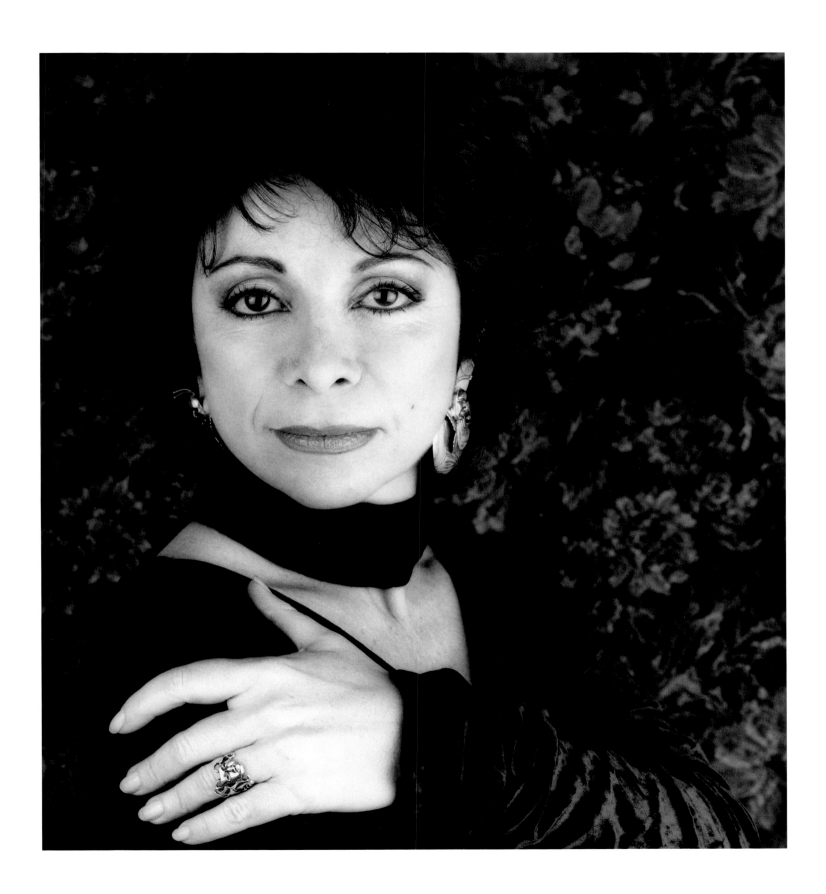

AFTERWORD

The women whose portraits and biographies appear in these pages have given this world something of meaning. Through their intelligence, energy, and passion, they have made enormous contributions, bettering the lives of many.

Though each woman is nationally or internationally famous within her field of expertise, I was not, when deciding to do this project, interested in fame. I am, rather, fascinated with accomplishment, especially that accomplishment which becomes a positive force in the lives of many others; this factor, extraordinary and rare, astonishes me, and it drew me to and led me through this work.

I don't believe that any of the subjects accomplished what they did because they decided to. Rather, remarkable accomplishment comes, I believe, as a result of a complicated set of forces and circumstances. In a way, it is mysterious. A basic intelligence, gift or ability, mixed with the proper education and honing of skills are, of course, essential to any remarkable achievement. But, what it really takes is a driving force that makes one sit in one place, work unceasingly, ignore appetites of all sorts, and sacrifice sleep, social engagement, and the many other temptations of life. In my opinion, this relentless, passionate effort is the key ingredient for such achievement.

My quest was to find this passion, to learn about it, to feel it. I lit the photographs to burn with it.

Howard Schatz

ACKNOWLEDGMENTS

Diana Cohen, a professional public relations manager, with over fifteen years experience in the arts, including a number of years with the Oakland Symphony, was the participant co-ordinator. Her work began each adventure that became a portrait. Her gentle determination, unerring and filled with joy, made this entire project possible.

A special acknowledgment goes to Patti Levey. Thanks to Jerome Vloeberghs for his fine little brush and to Mica, for his exacting pencils. Thanks to Paul Singer and to Michael Krasny for their thoughtful contributions to this project. Tekno-Balcar in Los Angeles and Chicago (Ken Lerner) were especially helpful. Thanks also to Gordon Hammer, Deborah Hammond, Chris Tuger, Nancy Koc, and Laura Jacobs. The many people at Gasser's (especially Ernie, Alex, Tony and Martin) and Gamma, were always "pulling" for this project. Master photographer, Paul Bishop of Berkeley, reviewed some of the first portraits and had the good grace to ask for one for his own collection. Owen Deutsch, former fashion photographer (Chicago) and my great friend, helped me in the fetal stages of this project.

San Francisco Focus Magazine was first to publish a number of these portraits in their cover story on remarkable women in the San Francisco Bay Area. Thanks particularly to Art Director, Mark Ulriksen, and Executive Editor, Amy Rennert.

The Vision Gallery in San Francisco premiered the *Gifted Woman* series in a show in 1991; I owe an enormous debt of gratitude to Joe Folberg, owner and curator of Vision, for showing my work. Thank you also to Nic Planchon for preparing the show.

ABOUT THE PHOTOGRAPHER

Howard Schatz is a San Francisco photographer. His current projects include the "Homeless," "Newborns" and a series on "Dancers." The "Gifted Woman" series is in the permanent collection of the Oakland Museum.

He has recently completed *Seeing Red*, a photographic book of redheads (in color, of course). His work is exhibited at the Vision Gallery in San Francisco.

Schatz's photographs have been published in:

Photo Review
Photographer's Forum Magazine
1990 and 1991 Best of Photography Annual
Photo Technique International (European and English Editions)
Profil
Hasselblad Forum
PhotoGraphic Magazine
Image Magazine
Frisko Magazine
San Francisco Focus Magazine
Harper's Bazaar

ABOUT THE EDITOR / PROJECT ADMINISTRATOR

Beverly Ornstein is an award-winning television producer and former Director of News and Current Affairs at KQED Television in San Francisco. She is now the Publisher of Pacific Medical Press and Pacific Photographic Press in San Francisco.

In June of 1991 The Oakland Museum History Department received a gift of 50 photographic portraits of prominent Bay Area women from a generous patron. *The Gifted Woman* series, photographed by Howard Schatz is now a part of the museum's permanent collections. The mission of The Oakland Museum is to interpret the story of California and its people by means of a multi-disciplinary approach focusing on the state's history, visual arts, and diverse cultural composition. This fine collection of portraits beautifully fulfills all of the above criteria. We are proud to have them as part of our permanent collection.

Marcia Eymann
Oakland Museum